DALI

(DALI)

Christopher Masters

Phaidon Press Limited
Regent's Wharf, All Saints Street, London N1 9PA

First published 1995
© Phaidon Press Limited 1995

A CIP catalogue record for this book is available from the British
Library

ISBN 0 7148 3338 X Pb
ISBN 0 7148 3339 8 Hb

Printed in Singapore

Cover illustrations:
Front: *The Persistence of Memory*, 1931 (Plate 19)
Back: *Sleep*, 1937 (Plate 31)

The publishers would like to thank all those museum authorities and
private owners who have kindly allowed works in their possession to be
reproduced. All works by Salvador Dalí are © Estate of Salvador Dalí.

Note: All dimensions of works are given height before width.

Dalí

The Spanish painter Salvador Dalí remains one of the most controversial and paradoxical artists of the twentieth century. A painter of considerable virtuosity, he used a traditional illusionistic style to create disturbing images filled with references to violence, death, cannibalism and bizarre sexual practices. In the late 1920s and 1930s he was associated with the Surrealists, the most revolutionary artists of the time. Throughout most of the 1920s the Surrealists practised what they described as automatism – writing or drawing executed without any conscious control, through which they attempted to free themselves from the constraints of reason. Dalí himself had little sympathy with automatism and always composed his paintings with great deliberation. Nonetheless, the imaginative power of his imagery was so great that by 1929 the Surrealists' leader André Breton admitted: 'It is perhaps with Dalí that for the first time the windows of the mind are opened fully wide.' For much of the next decade, Dalí had a profound influence on Surrealist ideas and activities. However, by the early 1940s Breton, the so-called Pope of Surrealism, had excommunicated Dalí from his movement, deriding his commercial success in the United States by memorably christening him 'Avida Dollars'. Dalí's own remarks in 1940 were equally curt: 'The difference between me and the Surrealists is that I am a Surrealist.' In fact Dalí had also begun to show sympathy with Roman Catholicism, and had even produced certain paintings, such as *The Enigma of Hitler* of 1937 (Fig. 31), which appear to adopt a profoundly ambiguous attitude towards the rise of Nazism.

While Dalí's references to Hitler in his paintings were limited to the 1930s, his interest in religious imagery increased in the post-war period, culminating in the *Christ of St John of the Cross* of 1951 (Plate 40). Based on a drawing by a sixteenth-century Spanish mystic, in which Christ is shown hanging from a cross in the sky, it demonstrates the way in which Dalí's work could simultaneously attract critical disdain, a high purchase price and massive popular interest: after it was bought by Glasgow Art Gallery it was slashed by a hostile visitor, usually the mark of a painting of extreme cultural importance or outrageousness. Above all, this picture exemplifies the strength of Dalí's adherence to his Spanish Catholic roots. Indeed the apparent contradictions in Dalí's career can perhaps be best explained by an analysis of his early life, in which traditional Spanish values vied with the influence of radical modern ideas.

Salvador Dalí y Domenech was born on 11 May 1904 at Figueras in Catalonia; his father, a public notary, had republican atheist views, while his mother was a devout Catholic. Whatever their ideological differences, his parents were united in believing that their son was the reincarnation of an earlier child, also called Salvador, who had died a year previously. Dalí vividly describes the traumatic effects of this belief in his autobiography, *The Unspeakable Confessions of Salvador Dalí*:

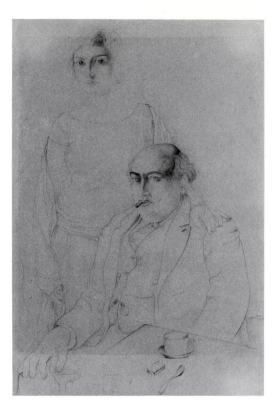

Fig. 1
The Artist's Father
and Sister
1925. Pencil on paper,
49 x 33 cm. Museu d'Art
de Catalunya, Barcelona

'I learned to live by filling the vacuum of the affection that was not really being felt for me with love-of-me-for-me; I first conquered death with pride and narcissism.' From this account it seems clear that although Dalí's parents were in fact extremely loving, their obsession with his dead brother caused lasting psychological damage. This is not to say that one should take too literally everything that is written in either *The Unspeakable Confessions of Salvador Dalí* or his earlier autobiographies *The Secret Life of Salvador Dalí* and *Diary of a Genius*. *The Secret Life of Salvador Dalí* even has a chapter devoted to what Dalí himself called 'false' memories. In the case of *The Unspeakable Confessions of Salvador Dalí* his autobiographical statements were written down by his friend André Parinaud, creating what Parinaud described as 'a Dalinian novel'. Although some of Dalí's reminiscences undoubtedly have a fictional, rather than factual, quality, they remain invaluable as a means of understanding his thinking, in particular the way in which he sought to mythologize his life. Dalí's childhood was an especially fertile area of invention for an artist who wished to interpret so much of his work in relation to his earliest experiences. Fortunately the memoirs of Dalí written by his younger sister Ana Maria provide an alternative account of this period: while Dalí described his early life as assailed by a host of traumas, his sister's record is of a happy, secure childhood.

As well as their comfortable house in Figueras, the Dalís owned a property on the Costa Brava at Cadaqués, the birth place of Dalí's father, where they spent their summers. Cadaqués provided the ideal environment for someone with Dalí's intense aesthetic sense; it was already much visited by artists, including Pablo Picasso (1881–1973), who stayed there in 1910 with the Pichot family. The Pichots were also friends of Dalí's father and provided the earliest significant encouragement for the young Salvador's artistic talent. In 1916 Salvador, then only 12, spent several weeks with Pepito Pichot just outside Figueras, where he became entranced by the works of Pepito's brother Ramon, who worked in a style derived from both Impressionism and Pointillism. Ramon Pichot (1872–1925), a successful artist who divided his time between Paris and Cadaqués, was Dalí's first important role model and his influence can be seen in the colour-scheme of such works as the *Self-portrait with Raphaelesque Neck* (Plate 1). In 1916 Pichot also persuaded Dalí to attend drawing classes given by the academic painter Juan Núñez at the Municipal Drawing School in Figueras.

Certainly Salvador's artistic studies were more consistent than the rest of his education. He had begun his schooling in 1908 at the local state kindergarten, where he was surrounded, as he described it, by 'the poorest children of the town, which was very important, I think, for the development of my natural tendencies to megalomania'. However, this experience was of little educational value, and as a result in 1910 his father, despite being an atheist, moved him to a private Catholic primary school. This appears to have made little difference; only when Dalí started secondary school in 1916 did he begin to get good marks, better in fact than he was later prepared to admit. Nevertheless, he was always far more interested in painting and drawing than in academic work. A canvas that he produced in 1914 after a work by the nineteenth-century Spanish artist Manuel Benedito illustrates his early admiration of academic painting, which was to influence his technique throughout his career, even when his subject-matter underwent the most extreme transformations. During his time at secondary school, from 1916 to 1922, Dalí was inspired mainly by the Impressionists, whose ability to capture fleeting conditions of light and colour influenced

the many landscapes that he produced in this period. As well as painting and drawing, Dalí also began a novel in 1920 and wrote poems, one of which was published in 1919. In the same year he also exhibited, to a favourable reception, in a group show organized in Figueras.

While Dalí's artistic career was already flourishing, he received a terrible emotional blow when his mother died from cancer in 1921. This was followed four years later by the remarriage of his father to his sister-in-law Tieta, with whom he had probably been having an affair even before his wife died. It seems likely that these traumatic events contributed to the resentment against his father that Dalí later expressed so memorably, if cryptically, in paintings such as *The Enigma of William Tell* (Plate 20). A more immediate battle with paternal authority resulted from Dalí's determination to pursue art as a career, to which eventually his father agreed. In return for this approval Dalí would obtain a formal training at the School of Fine Arts in Madrid, where his father expected him to obtain a teaching qualification. It was in Madrid that Dalí met the poet Federico García Lorca and the film director Luis Buñuel. Dalí's career soon began to stray from its anticipated course: within a year of his arrival in Madrid in 1922, he was suspended for having supposedly organized a minor student riot. In 1926 he declared his teachers incompetent to judge his work and was promptly expelled. Unfortunately for his father, this behaviour was only mildly unconventional in comparison with what was to follow later in the decade.

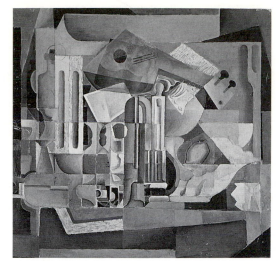

Fig. 2
Purist Still Life
1924. Oil on canvas,
100 x 100 cm.
Fundacio Gala-Salvador
Dalí, Figueras

From Dalí's point of view his expulsion was of little consequence. He later said that the school did not give him an adequate training in the academic tradition. At the same time, however, he became aware of avant-garde trends such as Cubism that made Impressionism, his fellow pupils' main stylistic model, seem completely outmoded. The Cubists rejected traditional illusionistic representation in favour of an autonomous pictorial language, consisting of flat, coloured planes. While Cubist influences are apparent in his *Self-portrait with La Publicitat* (Plate 2), his drawing of *The Artist's Father and Sister* (Fig. 1) has a linear, academic style reminiscent of the French artist Jean Auguste Dominique Ingres (1780–1867). It is clear that Dalí was already exhibiting that strange mixture of conservatism and radicalism that characterized his whole career. His exposure to avant-garde developments in France was in fact quite limited at this time. However, he did have access to the periodical *L'Esprit nouveau*, the organ of the artistic movement known as Purism, whose leaders included Charles-Édouard Jeanneret (1887–1965), who later became renowned as the architect Le Corbusier. The Purists, who regarded themselves as having built on the discoveries of Cubism, sought to analyse the formal qualities of their subject-matter, without distorting them. Dalí acknowledged their influence in his *Purist Still Life* of 1924 (Fig. 2). He also remained dedicated to his Spanish artistic heritage and just two years later produced another still life, *Basket of Bread* (Fig. 3), which demonstrates spectacularly the influence of Spanish painters such as Diego Velázquez (1599–1660).

Fig. 3
Basket of Bread
1926. Oil on panel,
31.5 x 32 cm.
Salvador Dalí Museum,
St Petersburg, FL

Dalí did much of his most memorable work at this time during his summers in Cadaqués, which was always a potent source of inspiration for his art. The strange rock formations of the shore were later to influence the form of the enormous sleeping head in *The Great Masturbator* (Plate 15). Cadaqués also provided the setting for a series of idyllic works depicting Dalí's sister Ana Maria (see Plates 5 and 6). Throughout Europe there was a resurgence of classical styles at this time, even among artists such as Picasso, who were associated with the avant-garde. Moreover, Dalí's portraits of Ana Maria also reflect the

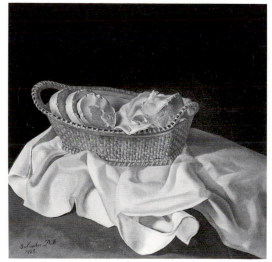

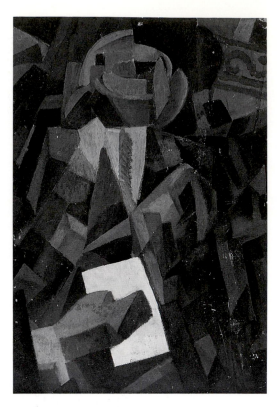

Fig. 4
Portrait of Federico
García Lorca
*c*1923. Oil on cardboard,
74.6 x 52 cm.
Fundacio Gala-Salvador
Dalí, Figueras

work of the Catalan painter Joaquim Sunyer and other members of the movement known as Noucentisme, who had been producing sensual classical paintings of Mediterranean subjects even before the First World War. The intense charm of Dalí's paintings was shattered, however, by the grotesque *Figure on the Rocks* of 1926 (Plate 7), in which the deliberately graceless figure of Ana Maria is clearly influenced by the most recent work of Picasso, whom Dalí had just met during his first visit to Paris. Even before this encounter Dalí had demonstrated his knowledge of the development of Picasso's work in *Venus and Sailor (Homage to Salvat-Papasseit)* (Plate 4), which he had exhibited in 1925 at the Dalmau Gallery in Barcelona. This painting, with its discordant composition and explicit eroticism, contrasted greatly with the elegant portraits of Ana Maria that were displayed in the same exhibition.

The extreme diversity of Dalí's work in this period was undoubtedly intended to excite attention through its 'explosive paradox', as one critic described it. This was particularly obvious in Dalí's second exhibition at the Dalmau Gallery in 1927, which included the *Composition with Three Figures (Neocubist Academy)* (Private collection). While referring to Renaissance iconography, this work also shows the influences of both Cubism and Picasso's contemporary paintings of female figures. The male form in the centre of the picture has been interpreted as representing the martyr Saint Sebastian, with whom Dalí somewhat immodestly identified himself. It has also been claimed that the plaster cast beneath the saint combines the features of both Dalí and the poet Lorca. The two were very close at this time; Lorca frequently stayed with Dalí in Cadaqués, and their collaboration included the production of Lorca's play *Mariana Pineda* in Barcelona in 1927, for which Dalí designed the sets and costumes. Lorca encouraged Dalí's experimentation with Cubism and indeed appears to have been the subject of one of Dalí's early Cubist portraits (see Fig. 4). Despite these artistic ventures, Lorca wrote in his *Ode to Salvador Dalí* of 1926: 'The light that blinds our eyes is not art. Rather it is love, friendship, crossed swords.' However, by the end of the decade the deep personal sympathy to which Lorca was referring had declined as Dalí adopted the radical innovations of Surrealism.

Although Dalí did not officially join the Surrealists until 1929, their influence can clearly be seen in his work of the previous two years. *Apparatus and Hand* (Plate 9) contains an array of highly ambiguous geometric and organic forms which were certainly inspired by the Surrealists Yves Tanguy (1900–55) and Joan Miró (1893–1983). Indeed Dalí briefly experimented with the styles of a number of Surrealist artists, including Max Ernst (1891–1976) and Jean Arp (1887–1966), before eventually arriving at his own personal idiom. Despite these associations, Dalí was initially unwilling to identify himself too closely with Surrealism. His work, however bizarre, was firmly based on the representation of objects from the real world, unlike early Surrealism, with its heavy reliance on automatism and its preoccupation with what Dalí described in 1927 as 'murky subconscious processes'. By the late 1920s the Surrealists' emphasis on automatism was in fact declining, as Breton's book *Surrealism and Painting* demonstrated in 1928. As a consequence Dalí began to consider the possibility of a closer association with the movement. The degree of his sympathy with Surrealism at this time can be gauged from the imagery of *The Spectral Cow* (Plate 11), which is clearly derived from a text by Breton.

While Dalí's work increasingly showed Surrealist influences, it was clear that he would have to go to Paris if he actually wanted to join the

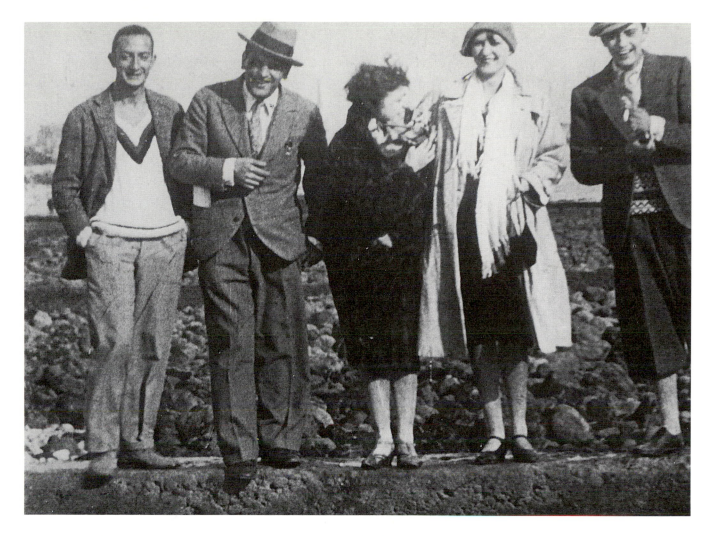

movement. However, his arrival in the French capital in April 1929 was in fact for another purpose, the filming of *Un Chien andalou*, on which he collaborated with his compatriot Buñuel (see Fig. 5). Dalí had been fascinated by the poetic possibilities of film-making for some time, and had written various texts on the subject in the Catalan review *The Friend of the Arts*. He was particularly interested in the use of techniques such as montage, which enabled a rapid transition between different images. He created an equivalent effect in certain of his paintings such as *Little Ashes* of 1928 (Plate 10), in which the large torso that dominates the composition is depicted as if captured in the process of metamorphosizing from one form to another. However, as *Un Chien andalou* demonstrated, cinema was in this respect a far more flexible medium than painting and was particularly suitable for the kind of provocative imagery that Dalí was increasingly favouring. As well as inspiring the celebrated scene in which an eye is sliced open with a razor, Dalí can be credited for the appearance of several putrefying donkeys (see Fig. 21), although his practical contribution to the making of the film was limited. According to Buñuel's autobiography, 'Dalí arrived on the set a few days before the end and spent most of his time pouring wax into the eyes of stuffed donkeys.' Certainly Dalí was inordinately fond of this particular motif. He had already included it in various paintings, including the *Rotting Donkey* (Private collection) of 1928, and at the end of making *Un Chien andalou* he complained that 'it needed at least half a dozen more rotten donkeys.' Despite this reservation, when it was finally given a public screening in October 1929, the film was an immediate success. Dalí and Buñuel collaborated again almost at once on the scandalous film

Fig. 5
From left to right: Salvador Dalí, Luis Buñuel, Simone Mareuil (actress), Jeanne Rucas (Mme Buñuel), Pierre Batcheff (actor) on the set of the film *Un Chien andalou*
1929. Photograph

9

Fig. 6
Lya Lys and a statue
1930. Still from the film
L'Age d'or

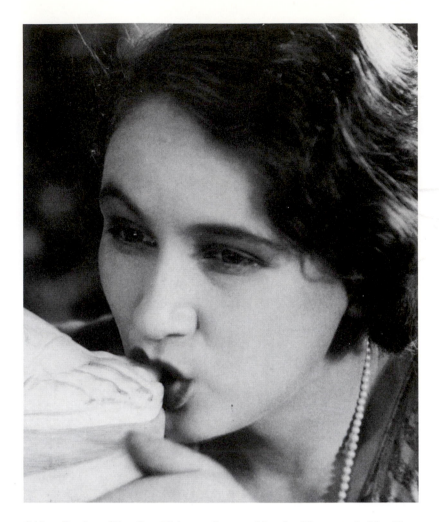

L'Age d'or (see Fig. 6), which was financed by the Vicomte de Noailles, one of Dalí's most important early patrons. Buñuel contributed more to the film than Dalí but, unfortunately, even before the film was completed, the relationship between the two Spaniards had rapidly deteriorated and they remained unreconciled for the rest of their lives.

As well as collaborating with Buñuel in Paris in the spring of 1929, Dalí also was introduced by his fellow Catalan Miró to various leading Surrealists and to the dealer Camille Goemans, who agreed to hold an exhibition of his work in the autumn. During the summer Dalí, now back in Cadaqués, worked feverishly on the paintings for this show, while entertaining Buñuel and a group of new friends from Paris, who included the Surrealist poet Paul Éluard and, more significantly, his wife Gala. In *The Secret Life of Salvador Dalí* the artist describes how he met Gala for the first time at the Hotel Miramar, where he had a drink with her and her husband. He then relates how on the following day he was captivated by her 'sublime back', which entranced him as had his nurse's when he was a baby. Dalí's fascination with women's backs had already been explored in his paintings of his sister (see Plates 5 and 6), and Gala's back, so 'athletic and fragile, taut and tender, feminine and energetic' was to be the subject of the memorable portrait of 1935 (see Plate 24). Despite this enthusiasm, Dalí's relationship with Gala was initially somewhat problematic. Although their mutual attraction was from the outset extremely strong, various obstacles had to be overcome. The fact that Gala was married to someone else does not appear to have been the greatest problem. Éluard returned to Paris in September, and was at first remarkably tolerant of Gala's affair with Dalí, just as he had been of her earlier relationship with the German Surrealist Ernst. Dalí returned the favour that year by making Éluard

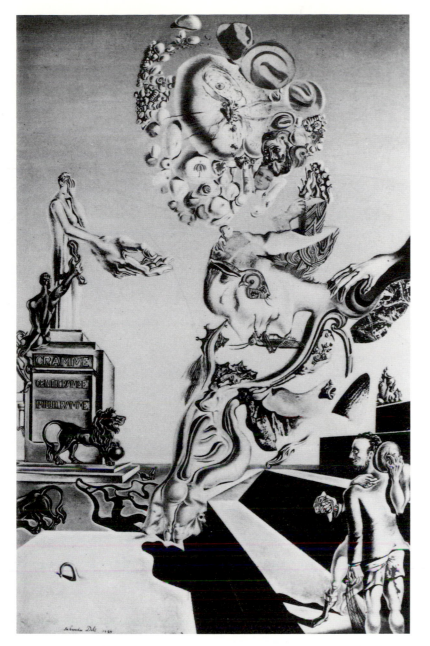

Fig. 7
Dismal Sport
1929. Oil and collage on
canvas, 31 x 41 cm.
Private collection

the subject of his first portrait in a Surrealist style. While Dalí's extraordinary provocative personality contributed to his powers of attraction, it also created various difficulties. Even Gala, open-minded as she was, was disturbed by the excrement on the underwear and leg of the bearded man in *Dismal Sport* (Fig. 7), which was Dalí's major painting of the summer of 1929. Fortunately Dalí was able to reassure Gala that this particular image had no bearing on his own sexual tastes. Gala's own strong, unconventional personality undoubtedly aroused fear as well as love in Dalí, yet fundamentally he regarded her as a kindred spirit, whom he later described as 'my intimate truth, my *double* and my *one*'.

As Dalí's affair with Gala flourished, so also did his preoccupation with various forms of sexual neurosis. As well as having a guilty preoccupation with masturbation, he was obsessed by the fear of impotence, which was intensified by the beginning of his first full sexual relationship. He expressed these concerns repeatedly in paintings such as *The Great Masturbator* (Plate 15) and *Dismal Sport* (Fig. 7). In the latter work the statue on the left, with its enlarged right hand and face covered with shame, expresses Dalí's guilty feelings about masturbation, while the man in the bottom right, holding a bleeding

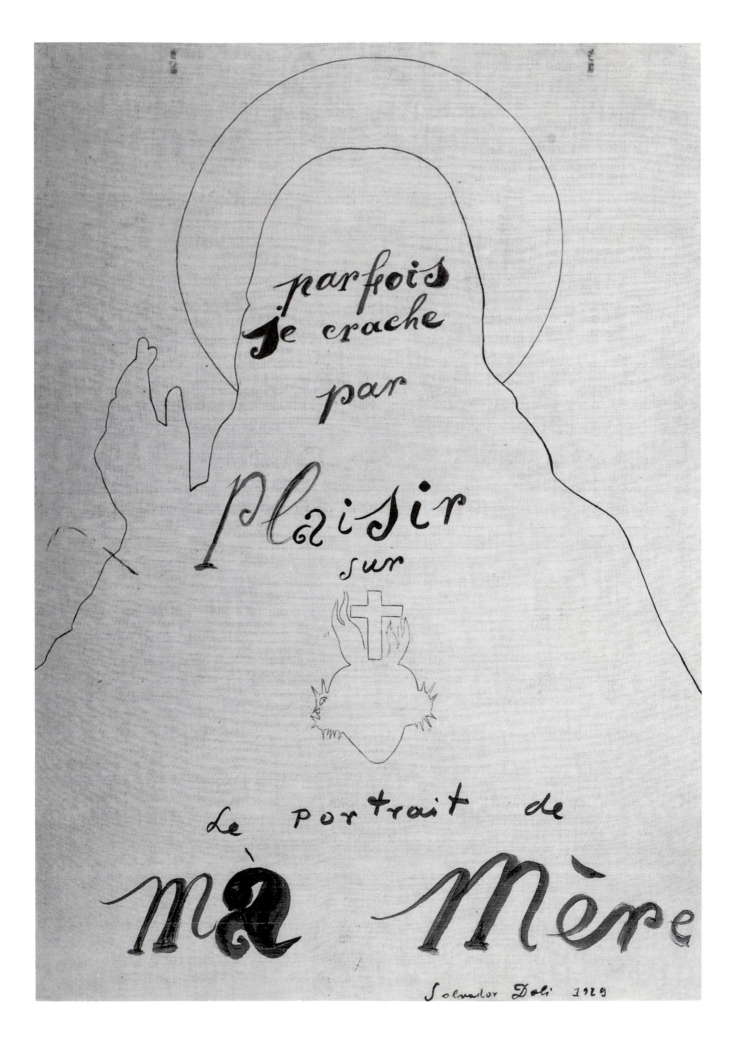

Fig. 8
The Accommodations
of Desires
1929. Oil and collage on
board, 22 x 35 cm.
Private collection

Fig. 9 (opposite)
The Sacred Heart
1929. Ink on canvas,
68.3 x 50.1 cm.
Musée National d'Art
Moderne, Centre Georges
Pompidou, Paris

bundle, represents the most terrible punishment, emasculation. Meanwhile, Dalí's sleeping head floats in the centre of the composition, surrounded by enigmatic dream-like imagery.

In such works Dalí's iconography was deliberately designed to invite interpretaton based on the principles of Freudian psychoanalysis, which was at that time a fashionable intellectual trend, particularly among the Surrealists and their patrons. Dalí had first read Freud's *The Interpretation of Dreams* when he was a student in Madrid, and much of his work of the late 1920s and 1930s is dominated by Freudian thought. This influence can be seen in specific motifs, such as the lion, the Freudian symbol of violence, passion and authority, which appears most dramatically in *The Accommodations of Desires* (Fig. 8). Dalí frequently provided strong clues as to the significance of a particular image; for example *Illumined Pleasures* (Plate 14) includes a woman's head which Dalí turned into a jug by adding handles, thus making a reference to Freud's idea that receptacles represent women when they appear in dreams. Other motifs like the grasshopper clinging to Dalí's mouth, which also appears in *The Great Masturbator* (Plate 15), recall more personal childhood phobias. The autobiographical element of Dalí's work is particularly marked in *The First Days of Spring* (Plate 13), in which enigmatic references to Dalí's various obsessions, including the grasshopper, are arranged around a photograph of himself as a child.

Towards the end of 1929 these paintings were finally displayed at the Goemans Gallery in an exhibition of 11 works which effectively marked Dalí's reception into the Surrealist movement. While repeating the Surrealists' reservations about the excrement in *Dismal Sport* (Fig. 7), André Breton's preface to the exhibition catalogue was mostly enthusiastic, and from that point Dalí became closely associated with the Surrealists. His relationship with his father, however, detoriated sharply, reaching a crisis in the Christmas of 1929, when the elder Dalí expelled him from the family house at Figueras, as a result of his exhibition in November of a canvas (see Fig. 9) on which he had written: 'Sometimes I spit with pleasure on my mother's portrait.' Dalí's initial response to his father's anger was to shave his hair in shame and bury it on the beach at Cadaqués. He also linked his troubles with his father to the legend of William Tell, the Swiss archer who was compelled to shoot an apple placed on his son's head at 200 paces. For Dalí this myth symbolized the fear of castration of a son by his father, which consequently formed the subject of several paintings whose titles refer to William Tell, even though they do not represent the legend itself. In *William Tell*

Fig. 10
William Tell
1930. Oil and collage on
canvas, 113 x 87 cm.
Private collection

(Fig. 10) the only way of identifying the hideous father-figure as William Tell is a label stuck to his leg. However, there is no ambiguity about the nature of the weapon that he is holding, and it is clear that the intended target is his son's virility.

As well as executing the William Tell paintings, Dalí also produced a series of works based on *The Angelus* (Fig. 26) by the French Realist painter Jean-François Millet (1814–75). According to Dalí, this seemingly sentimental image of a peasant couple praying in a field at dusk is filled with repressed violence and sexuality. Dalí claimed that, far from being a model of piety, the woman is in fact about to destroy her companion, who, with a characteristic Freudian twist, is supposed to represent both lover and son. Dalí's interpretation of Millet's painting exemplified his new technique of 'paranoia-criticism', which he began to develop in late 1929, even though he did not use this term until 1933. In Dalí's words, paranoia-criticism was a way of gaining 'irrational knowledge based upon the interpretive-critical association of delirious phenomena'. Millet's *The Angelus* proved to be an especially fertile source of these experiences, all of which he related to his initial realization of the painting's sinister meaning in 1932. Dalí described this succession of extraordinary intuitions in his book *The Tragic Myth of Millet's Angelus*, written in 1938, although not published until 1963. A particularly significant incident occurred when Dalí saw a fragment of a coloured print of cherries, which caused him to have a highly disturbing mental vision of *The Angelus*. Although Dalí's association of the cherries with the figures in *The Angelus* was, according to his own explanation, based on erotic symbolism rather than any visual similarity, he was also able to draw an analogy between the bowed figure of the peasant woman in Millet's painting and the form of a female praying mantis, the insect that devours its mate after copulation. Dalí was able to claim that his morbid interpretations of *The Angelus* were confirmed by X-rays of the painting that were taken after he wrote the book; these revealed a black shape, which suggested to Dalí that Millet had originally intended to represent the coffin of the peasants' son. While Dalí's book was not published until late in his career, his preoccupation with *The Angelus* was reflected in his own work of the 1930s. The similarity that he discerned between the shapes of the two figures in Millet's painting and menhirs in Brittany inspired the *Architectonic Angelus of Millet* of 1933 (Museo Nacional Centro de Arte Reina Sofia, Madrid), in which two enormous biomorphic rocks are substituted for the peasant couple. He also repeatedly referred to *The Angelus* in the illustrations that he made in 1933–4 for *The Songs of Maldoror* by the Comte de Lautréamont, one of the Surrealists' favourite writers. Dalí even related the sexual significance of *The Angelus* to his own relationship with Gala, and executed several works that included both depictions of Gala and miniature versions of *The Angelus*. A particularly bizarre example of this is *Gala and* The Angelus *of Millet before the Imminent Arrival of the Conical Anamorphoses* (Plate 21).

The striking similarity between Dalí's paranoia-criticism and the thought patterns of a maniac was not accidental. During his youth in Cadaqués, Dalí was profoundly influenced by a peasant woman called Lydia Nogues, the victim of an obsessive passion for the art critic Eugenio d'Ors, who had once stayed with her when he was still a student. Although she never saw him again, she devotedly collected his writings, which she was convinced contained secret messages intended for her alone. Dalí himself said that 'no one more than she – except for me – knew so firmly how to maintain the systematization of delirious thought within the most remarkable coherence.' It is hardly

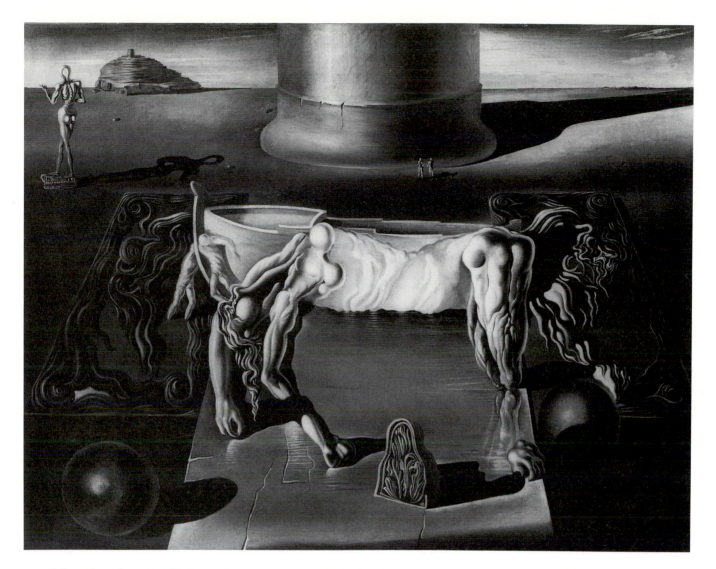

surprising, therefore, that Dalí gave her the distinguished title of 'god-mother to my madness'.

Of course Dalí's cultivation of delirium was to some extent artificial: as he pointed out, 'The only difference between myself and a madman is that I am not mad.' The simulation of psychological disorders was a recurrent Surrealist technique, in which Breton was particularly interested. The Surrealists' leader was initially a fervent supporter of paranoia-criticism, which he claimed could be applied with equal success to a wide range of activities, including painting, poetry, the cinema 'and even, if necessary, to all manners of exegesis'. However, it eventually became clear that Dalí was primarily concerned with its application to painting. In particular he used it to justify his preoccupation with double images, forms that could be interpreted as simultaneously representing more than one subject. He claimed that the imaginative associations of objects that inspired these works exemplified his paranoiac-critical method. Following his earliest full-scale attempt at the double image, *The Invisible Man* of 1929–33 (Plate 16), Dalí pursued the technique still further in *Invisible Sleeping Woman, Horse, Lion, etc.* (Fig. 11) of 1930; the title indicates the extent to which a single form could be made to carry not only double but multiple meanings.

Despite the ingenuity of these images, it is not difficult to see why Breton was eventually moved to criticize Dalí for constructing mere 'crossword puzzles'. This is not to say that paranoia-criticism never rose above the level of creating visual tricks, as can be seen from the

Fig. 11
Invisible Sleeping
Woman, Horse,
Lion etc.
1930. Oil on canvas,
50.2 x 65.2 cm.
Musée National d'Art
Moderne, Centre Georges
Pompidou, Paris

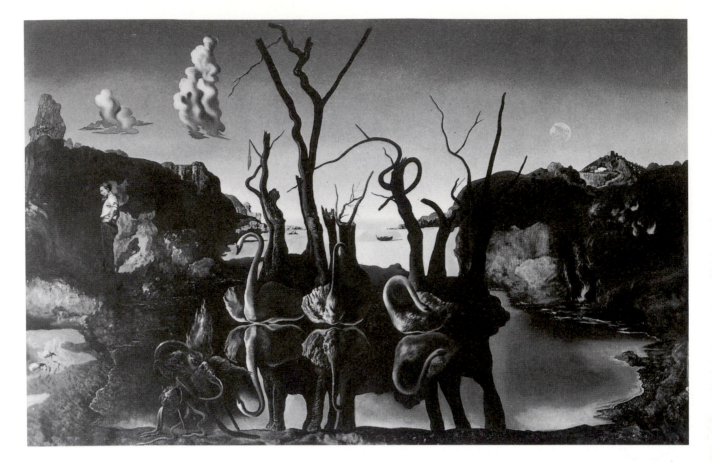

Fig. 12
Swans Reflecting
Elephants
1937. Oil on canvas,
51 x 77 cm.
Private collection

extraordinary iconography of *Suburbs of the Paranoiac-critical City: Afternoon on the Fringes of European History* (Plate 27), which does not in fact contain any true double images. Perhaps the most remarkable of Dalí's paranoiac-critical paintings is *The Metamorphosis of Narcissus* (Plate 30) of 1937, whose complex sequence of visual associations was accompanied by a remarkable poem on the same subject. In the same year Dalí also produced *Swans Reflecting Elephants* (Fig. 12). Looking at this painting, visual rather than visionary in its appeal, one can understand why Breton said in 1941 that Dalí's work 'from 1936 onwards has had no interest whatsoever for Surrealism'.

Although certain of Dalí's paranoiac-critical paintings may have failed Surrealism, he did lead the movement in the creation of Surrealist objects, in which things belonging to mundane reality were removed from their original context and brought together in strange combinations in order to create a new surreality. The re-use of everyday objects was anticipated by Marcel Duchamp (1887–1968), who had created ready-mades out of urinals and shovels while he was in America during the First World War. However, Dalí's aim was to produce objects with a far greater power to express their creator's 'amorous imagination' and unconscious desires. Dalí first articulated his ideas in 1931 in an article published in the periodical *Surrealism in the Service of the Revolution*, where he defined six kinds of Surrealist objects, accompanied by photographs of examples by various leading Surrealists. Many of Dalí's own objects were to pursue obsessions that also appeared in his paintings; for example *Lobster Telephone* (Plate 26) juxtaposes two of Dalí's favourite fetishes – lobsters and telephones.

While the telephone was small and eminently collectable, Dalí also created larger objects, whose life-span was only as long as the exhibitions for which they were made. A particularly disgusting, yet effective, example was the *Rainy Taxi* created in 1938 for the Second International Surrealist Exhibition in Paris. The taxi had holes in its

roof through which water poured onto 'a Venus lying among the lichens, and driven by a monster', a perfect complement to the toucan-headed mannequin that Dalí installed, together with dummies decorated by other Surrealists, elsewhere in the exhibition. The First International Surrealist Exhibition, held in London two years previously, had also given Dalí the opportunity to display Surrealist objects. However, his most memorable contribution to this event was the speech that he gave in a diver's suit, in order 'to symbolize the unconscious', which nearly resulted in his asphyxiation. The audience failed to appreciate the gravity of the situation and when Dalí was eventually released from his outfit they 'went wild with applause before the total success of the Dalinian mimodrama which in its eyes apparently was a representation of the conscious trying to apprehend the subconscious'. As the artist caustically added in *The Unspeakable Confessions of Salvador Dalí*: 'I almost died of this triumph.'

According to Dalí's own account, the 'sensation of angst' which this accident gave him was aggravated by his horror at a tragedy of far wider significance, the Spanish Civil War, whose victims included his old friend Lorca. Even before war had broken out, Dalí represented Spain's self-destructive qualities in the monumental *Soft Construction with Boiled Beans: Premonition of Civil War* (Plate 28), followed soon afterwards by *Autumn Cannibalism* (Plate 29). While these paintings express a profound anguish at the events in his native country, they do so by depicting the war as a 'phenomenon of natural history', in which monstrous creatures strangle or devour themselves. Dalí's unwillingness to adopt a committed political stance against the rise of Fascism had already become the most significant element in his ever worsening relations with the other Surrealists, who supported revolutionary Communism. As early as 1934 Dalí had been summoned to a meeting where he was accused of 'counter-revolutionary actions involving the glorification of Hitlerian Fascism'. His offences were also deemed to include his painting *The Enigma of William Tell* (Plate 20), in which Lenin was represented with an enormous buttock supported on crutches, an image that was construed as being less than respectful. On this occasion he managed to escape expulsion from the Surrealist movement by swearing that he was not a Fascist. The incident was complicated by the fact that Dalí was ill with a fever, and, always a hypochondriac, insisted on keeping a thermometer in his mouth throughout the interrogation. In the course of the meeting he also gradually removed several layers of clothing, forming a thick carpet of sweaters on which he eventually knelt to make his oath. 'I had transformed the grotesque occasion into a true Surrealist happening,' he later remarked. 'Breton would never forgive me for it.'

Dalí's lack of sympathy for the political aspirations of Surrealism had also been intensified by his involvement in the bitter rows that took place during the 1930s between the Communist Party and the Surrealists. Much to his distaste he was the unwitting cause of the rupture between Breton and his former friend Louis Aragon as a result of the publication in 1931 of one of Dalí's writings in *Surrealism in the Service of the Revolution*. Through Aragon, the Communists attempted to suppress these writings, whose reliance on masturbation as their main source of inspiration offended Party scruples. On this occasion Breton in fact supported Dalí against such prudish condemnation, but Dalí's disgust at the political threat to his artistic freedom soon led to irreconcilable disagreements between himself and Breton. Moreover, his feelings were intensified when his close friend the Surrealist writer René Crevel committed suicide in 1934 after his failure to arrange a reconciliation between the Surrealists and the more orthodox

Fig. 13
Corpuscular Madonna
1952. Pencil, sepia and
indian ink on paper,
55.6 x 43.2 cm.
Museum of Art,
Birmingham, AL

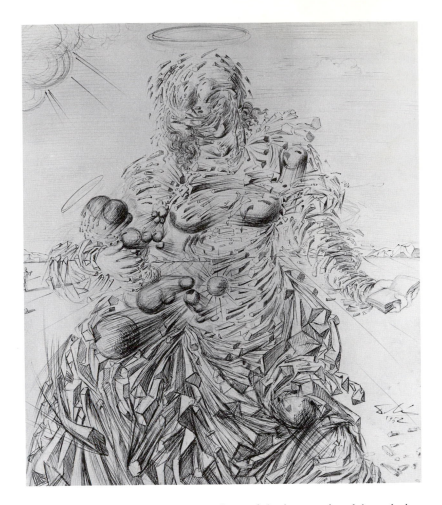

Communist artists who were members of the international Association
of Revolutionary Writers and Artists.

After such traumas Dalí's eventual divorce from the Surrealists at
the end of the 1930s was of little consequence to him. Just as he had
come to Paris in 1929 in order to make his name, so he later turned his
attentions to America, where he found not merely fame but fortune as
well. By the time he made his first visit to New York in 1934, the
Museum of Modern Art had already acquired one of his paintings, the
celebrated work, *The Persistence of Memory* (Plate 19), and on his arrival
he was greeted as a celebrity by Manhattan society. During other
visits later in the decade he created window displays for the fashion-
able Bonwit-Teller store on Fifth Avenue and in 1939 designed a
pavilion for the International World Fair, an exhibition of commerce,
design and technology. For the latter project Dalí proposed to fill an
enormous water tank with an extraordinary array of objects only tan-
gentially connected with the installation's title, the *Dream of Venus*
(see Fig. 30). Unfortunately the organizers were unable to accept that
The Birth of Venus by Sandro Botticelli (*c*1445–1510) could be repre-
sented with a fish's head on the exterior of the pavilion, and conse-
quently Dalí resigned, immediately justifying himself in a pamphlet,
the *Declaration of the Independence of the Imagination and of the Rights of
Man to his own Madness*. Such controversy naturally enhanced rather
than damaged his popularity in America, as became clear when he
moved there in 1940 in order to escape the Second World War.

Dalí's eight years in America offered enormous scope for his various
talents. As well as having an important retrospective exhibition at the
Museum of Modern Art in New York in 1941, Dalí collaborated on
several ballets, including the first 'paranoiac' ballet *Mad Tristan*. He
also worked in Hollywood on two films, Alfred Hitchcock's

Spellbound, for which he created a memorable dream sequence, and Walt Disney's animated movie *Destino*, which sadly was never completed. The speed at which he was working at this time is indicated by the fact that he was able to write two books, *The Secret Life of Salvador Dalí*, and his only finished novel, *Hidden Faces*, an elegiac tale about a group of French aristocrats confronted by the outbreak of the Second World War. Although its mannered, archaic style has not been universally admired, the novel is a revealing document of Dalí's own feelings about the period of social upheaval through which he was living.

All this frenetic activity did not prevent Dalí from painting, fortunately for a clientele distinguished by its enormous wealth. He entered a new phase as a society portrait-painter. Works such as the *Portrait of Frau Isabel Styler-Tas* (Plate 37) exemplify the way in which the double images of paranoia-criticism could be combined with explicit references to the work of the Old Masters. Dalí had of course always valued the technique of nineteenth-century academic artists, whose illusionism was so well suited to his Surrealist paintings – the 'hand-coloured photographs' of his delirium. During the War, on the other hand, he returned with renewed vigour to the paintings of the Italian Renaissance, whose harmonious, geometric compositions and religious imagery are also reflected in much of his later work. His passion for Italian art had undoubtedly been encouraged by the trips that he made to Italy shortly before the outbreak of war, but it is also certain that he saw his increasing reliance on tradition as a defence against contemporary horrors. As he described it: 'The climate of decomposition that was all about me led me to crystallize my art with so exclusive a passion that I forgot the rest of the world. Which was one of the aims.'

Despite Dalí's desire to be oblivious to the disasters that were afflicting Europe, it would be a mistake to regard his renewed classicism as merely a retreat from reality, for his interest in the spirituality of the religious art of the Renaissance was intimately linked to his understanding of the most recent scientific discoveries. For Dalí the development of nuclear physics, made manifest by the dropping of the first atom bomb in 1945, exerted a profound influence that was immediately reflected in his post-war work. Nuclear fission was, in Dalí's eyes, a discovery of profound metaphysical importance which he combined with his already emerging interest in Catholicism. In *The First Study for the Madonna of Port Lligat* (Plate 39) the image of the Virgin and Child is split into several sections in order to create a rather superficial metaphor for the divisibility of matter. As well as his interest in atomic particles, during the 1950s Dalí also developed an obsession with the mathematical shape known as the logarithmic spiral, which, he claimed, provided the basic structure of a whole range of natural objects, in particular the horn of the rhinoceros. In *The Unspeakable Confessions of Salvador Dalí* he describes how in 1955, while ostensibly copying *The Lacemaker*, a painting by the Dutch artist Jan Vermeer (1632–75) in the Louvre, he instead painted a pair of rhinoceros horns, stupefying the museum's curators and surprising himself. Later in the year he finally realized that the Vermeer and the horns had a common logarithmic structure, a discovery that he presented, to rapturous applause, in a lecture at the Sorbonne in Paris. Dalí's enthusiasm for the rhinoceros and the 'cock standing on the end of his nose' was in fact already well established. Both *Corpuscular Madonna* (Fig. 13) and *Exploding Raphaelesque Head* of 1951 (Private collection) contain small horn-like shapes, which in the latter painting build up an image that doubles as both the head of the Virgin and the dome of the Pantheon in Rome.

Fig. 14
'Me Crazy? I am certainly saner than the person who bought this book.'
1954. Photograph of Dalí from *Dalí's Mustache: A Photographic Interview*

Dalí repeated this strange combination of Raphaelesque imagery and paranoia-criticism in his *Sistine Madonna* (Private collection) of 1958. This can be interpreted as representing either one of the works of the Italian Renaissance painter Raphael or an ear, depending on the distance at which it is viewed. Like *Exploding Raphaelesque Head*, the image is constructed out of smaller forms as a metaphor for the structure of matter and antimatter. In *Sistine Madonna*, however, these particles are mere dots, creating a superficial resemblence to the work of the American Pop artist Roy Lichtenstein (b. 1923). A far more straightforward link with contemporary avant-garde art can be discerned in *Velázquez Painting the Infanta Margarita with the Lights and Shadows of his own Glory* (Plate 45), which is obviously influenced by the vigorous, expressive brushstrokes of American Abstract Expressionists such as Jackson Pollock (1912–56). Despite its debt to Modernism, the painting pays special homage to Dalí's Spanish heritage, which dominated much of his post-war work. Dalí's patriotism did nothing to reconcile him with the other Surrealists, who as early as 1941 had condemned him for rediscovering 'Spain, penitence, Catholicism, classicism'. Indeed Dalí's nationalism was tainted with the worst evil of all, Fascism. While Picasso, for example, refused to return to a Spain ruled by General Franco, in 1948 Dalí moved back to Port Lligat, the bay at Cadaqués where he had bought a house almost 20 years earlier from Lydia Nogues. From this base he enthusiastically supported the General, with whom he was granted an audience in 1956, a distinction that was followed in 1964 by the award of the Grand Cross of Isabella the Catholic, one of Spain's most illustrious honours. In 1974 he even painted an equestrian portrait of the General's granddaughter, Carmen Bordiu-Franco.

Dalí's other principal sin from a Surrealist point of view was his rampant commercialism, which was certainly quite compatible with his classicism. In 1952, for example, he sold the *Christ of St John of the Cross* (Plate 40) to Glasgow Art Gallery for the then enormous sum of over £8,000. Although the price was criticized at the time, within six years the Gallery was able to claim that it had recovered this sum through admission fees and the sale of reproductions. If museums were able to realize large profits from Dalí's work, it is hardly surprising that his images were seized upon hungrily by commercial companies. A whole industry arose based on his designs for jewellery, tapestries and other luxury items, while publishers gave him lucrative commissions to illustrate books and magazines. His previously subversive art was even courted by governments and other official bodies: in 1966, for example, he commemorated the twentieth anniversary of the foundation of the United Nations with an image of tree-trunks, sprouting hands rather than branches, clutching each other tenaciously. The United Nations was, of course, not the only organization to exploit Dalí's talent for advertisement. This aspect of his career had first flourished in America during the War, when he had re-used the limp watches of his Surrealist days for various purposes, including the advertisement of a brand of hosiery. Later in his career he made personal appearances in television commercials, as in 1970, when his role consisted of rolling his eyes and saying: 'I am mad, I am completely mad...over Lanvin chocolates.'

Dalí's image as the insane genius undoubtedly became an essential quality of his marketability, and was fastidiously cultivated in the many interviews that he gave to the media, as well as in the hilarious book *Dalí's Mustache: A Photographic Interview*, which he made with the photographer Philippe Halsman in 1954 (see Fig. 14). He also was the subject in 1973 of an entertaining television programme by the British broadcaster Russell Harty. Harty's own account of the making of the

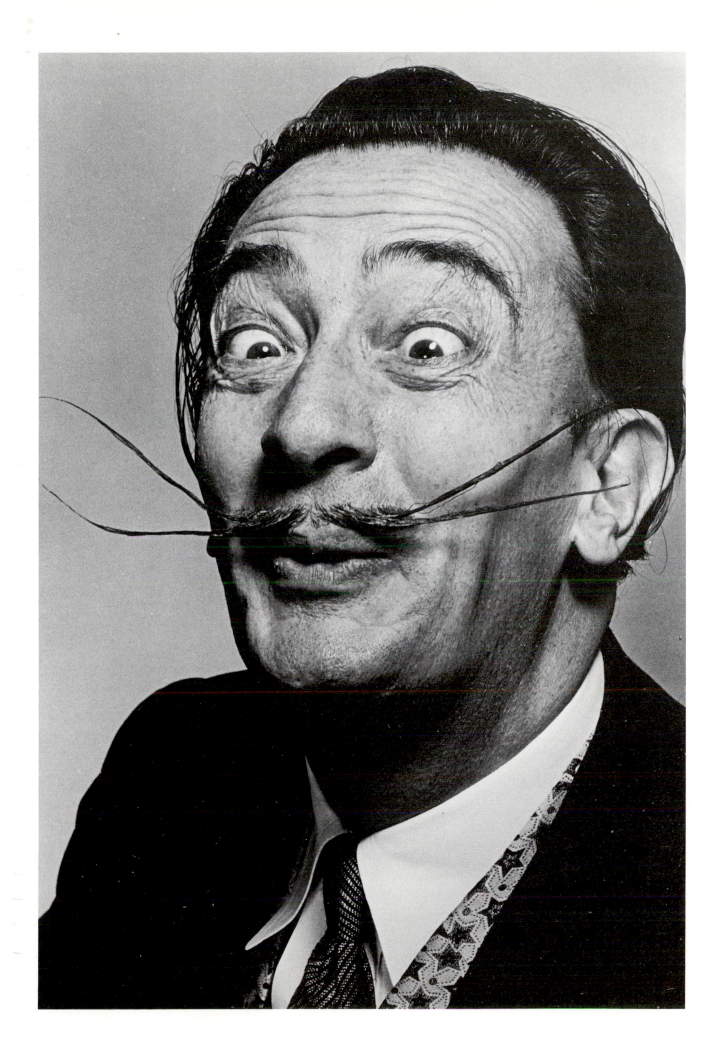

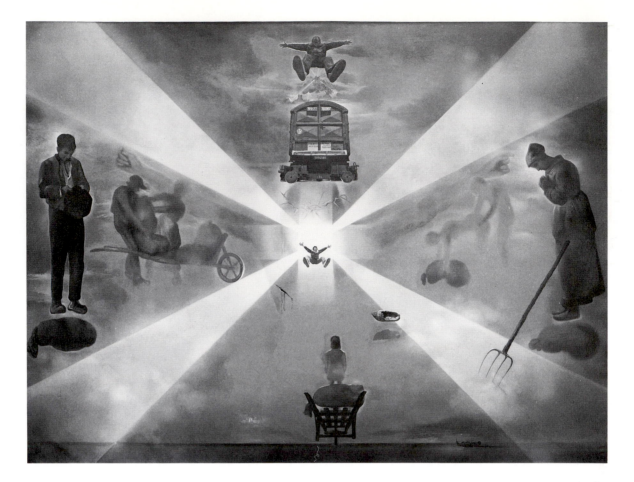

film is filled with references to Dalí's more eccentric habits, including his relationship with the two ocelots that were among his most long-suffering companions. As Harty related: 'Dalí wastes no opportunity of throwing them into the swimming-pool whenever they're passing. They do not appear to enjoy it.' Even cruelty to animals, however, was not Dalí's greatest passion. Harty added: 'Money is the most important thing in his thinking. He shouts loudly about his love of gold, dollars, cheques, pounds, pesetas. He never carries any around. He's like the Queen.'

Dalí's ostentation was particularly apparent in the decoration of his house at Port Lligat, which had a garden that might have come out of one of his paintings. According to Harty: 'There are banks of Pirelli tyre signs which light up at night, a violet sofa in the shape of Marilyn's lips...and in one wall, a piece of string which, when pulled, sets off Brahms's cradle song from a hidden musical box.' Harty's account also referred to the assorted hippies and 'inordinately smart Greeks from a yacht anchored in the bay' who were present when he visited Dalí, whose entourage also often included a variety of beautiful young women. While Gala remained remarkably tolerant of Dalí's dalliances, she maintained an indisputed dominance over his other affairs. Amanda Lear, one of Dalí's companions in his later years, wrote that Gala was 'everything to him: manager, business woman, cook, secretary, nurse and chauffeur. What devotion, I thought to myself.' Other accounts of Gala were less complimentary, blaming her at least in part for the commercialization of a once great artist.

Despite the vastness of the Dalí industry, the artist still found enough time to produce some monumental canvases in the 1960s and 1970s. Some of these explored well-established themes. In 1965, for example, *Perpignan Station* (Fig. 15) referred to Dalí's obsession with Millet's *The Angelus*, as well as to his conviction that the railway station

at Perpignan was the 'laboratory in which the absolute values of the universe can be followed', a conclusion that he reached after discovering that the metre measure had been established in that area. Dalí also revived his old technique of paranoiac-critical double images in *Hallucinogenic Toreador* (Plate 48). Other optical devices, however, had begun to interest him, and in the 1970s he experimented with stereoscopic paintings, such as *The Christ of Gala* of 1978 (Ludwig Museum, Cologne). In this work two almost identical canvases are viewed together through a stereoscope in order to create a single three-dimensional image. For Dalí this process had a quasi-spiritual significance: 'Binocular vision is the trinity of transcendent physical perception. The Father, the right eye, the Son, the left eye, and the Holy Spirit, the brain, the miracle of the language of fire, the luminous virtual image become incorruptible, pure spirit, Holy Spirit.' Dalí also produced holograms which he first exhibited in 1972 at the Knoedler Gallery in New York. Characteristically Dalí did not seek to use this technique merely to imitate everyday reality, as can be seen from *Holos! Holos! Velázquez! Gabor* (Fig. 16), in which an image of card-players is superimposed onto fragments from Velázquez's *Las Meninas* (Museo Nacional del Prado, Madrid). Although Dalí's interest in technical innovations was in itself admirable, his holograms were criticized for simply using a new medium as a vehicle for old mannerisms.

Dalí's most ambitious project at this time was the museum that he opened in the old theatre at Figueras in 1974. While preserving the building's prim classical façade, Dalí remodelled the interior, which had been ruined in the Spanish Civil War, and built a giant dome over the stage area. He then gathered together a fantastic assortment of objects, in which exuberant neo-Baroque decorations and some of his most famous canvases vie for attention with extraordinary gadgets. These include a sarcophagus, modelled on an ancient Chinese sculpture, covered with computer circuits (see fig. 17). As Dalí remarked: 'It's like a Paco Rabanne dress printed with circuits. What luxury!' With such an array of spectacular artefacts, it is perhaps not surprising that the Dalí Museum became the most popular museum in Spain after the Prado.

For most of his life Dalí's energy was prodigious, if not always well directed. In the late 1970s, however, his health declined sharply. His problems were compounded by a series of disputes about the authenticity of many of the prints carrying his signature. While neither his

Fig. 16
Holos! Holos!
Velázquez Gabor
1972–3. Hologram,
42 x 57 cm.
Fundacio Gala-Salvador
Dalí, Figueras

Fig. 17
Cybernetic Princess
1974. Computer circuits
and components,
length 2m. Fundacio
Gala-Salvador Dalí,
Figueras

own personal reputation nor his vast wealth were seriously threatened, such controversies must have caused him great anxiety. The worst of all calamities occurred when Gala finally died in 1982. Dalí retreated into the castle at Pubol which he had bought for his wife almost 15 years previously. At Pubol he suffered a final misfortune, when in August 1984 his bed caught fire as a result of an electrical fault. Despite a badly burned leg and a variety of other medical problems, Dalí lived on for another five years.

At his death Dalí was still undoubtedly the most famous artist in the world, even though his work received mixed reviews. Certainly Dalí was among his own most vocal admirers. When questioned in 1973 about his opinion of his ranking in the history of art, he answered simply: 'The First, the First'. With characteristic perversity he then added: 'That's not because Dalí is so good. It is because the others are so bad.' Dalí would undoubtedly have met a more sober, objective judgement with nothing but disgust. The extreme subjectivity of his own opinions is exemplified by his pronouncement in *The Unspeakable Confessions of Salvador Dalí* that 'the criterion of great art is that it produce an equivalence of the hazel colour of Gala's eyes.' However, even when judged by more conventional standards, Dalí must be regarded as among the most exuberant and individual of modern artists.

Outline Biography

1904 Salvador Dalí y Domenech born 11 May at Figueras in Catalonia.

1919 Exhibits with the Sociedad de Conciertos in Figueras.

1922 Begins training at the School of Fine Arts in Madrid, where he meets Federico García Lorca and Luis Buñuel

1925 Has first one-man exhibition at the Dalmau Gallery in Barcelona.

1926 Is expelled from the School of Fine Arts; visits Paris, where he meets Picasso.

1927 Designs the sets and costumes for Lorca's play *Mariana Pineda* in Barcelona.

1929 Arrives in Paris to film *Un Chien andalou* with Buñuel. In November he exhibits *Dismal Sport* (Fig. 7) in Paris, and joins the Surrealist movement. Begins his first full-length double image *The Invisible Man* (Plate 16).

1930 Writes *The Invisible Woman*.

1934 Narrowly escapes expulsion from the Surrealist movement. Makes first trip to the United States.

1936 Attends the First International Surrealist Exhibition in London. The worsening political situation in Spain is reflected in *Soft Construction with Boiled Beans: Premonition of Civil War* (Plate 28) and *Autumn Cannibalism* (Plate 29).

1938 Writes *The Tragic Myth of Millet's Angelus*. Creates *Rainy Taxi* for the Second International Surrealist Exhibition in Paris.

1939 Organizes the 'Dream of Venus' pavilion for the New York International World Fair and publishes the *Declaration of the Independence of the Imagination and the Rights of Man to his own Madness*.

1940 Flees to the United States.

1941 He writes his autobiography *The Secret Life of Salvador Dalí*. Retrospective exhibition at the Museum of Modern Art in New York.

1944 Publishes *Hidden Faces*.

1948 Returns to Europe.

1949 Gives *The First Study for the Madonna of Port Lligat* (Plate 39) to Pope Pius XII.

1952 Glasgow Art Gallery purchases the *Christ of St John of the Cross* (Plate 40) for over £8,000.

1956 Is granted an audience with General Franco.

1964 Is awarded the Cross of St Isabella the Catholic.

1972 Holds an exhibition of holograms at the Knoedler Gallery, New York.

1974 The Dalí Museum is opened at Figueras.

1979–80 Major retrospective exhibition is held at the Musée National d'Art Moderne, Centre Georges Pompidou, Paris.

1984 Dalí is badly burned in a fire in his castle at Pubol.

1989 Dalí dies 23 January in Figueras and is buried at the Dalí Museum.

Select Bibliography

Salvador Dalí, exhibition catalogue, Goemans Gallery, Paris, 1929

Salvador Dalí, *La Femme visible*, Paris, 1930

Salvador Dalí, *The Conquest of the Irrational*, New York, 1935

Salvador Dalí, *The Metamorphosis of Narcissus*, New York, 1937

Salvador Dalí, *Declaration of the Independence of the Imagination and the Rights of Man to his own Madness*, New York, 1939

Salvador Dalí, exhibition catalogue, Museum of Modern Art, New York, 1941

Salvador Dalí, *The Secret Life of Salvador Dalí*, New York, 1942

Salvador Dalí, *Hidden Faces*, New York, 1944

Fleur Cowles, *The Case of Salvador Dalí*, London, 1959

Ana Maria Dalí, *Salvador Dalí vu par sa sœur*, Paris, 1960

Salvador Dalí, *Le Mythe tragique de l'Angelus de Millet: interpretation 'paranoiaque-critique'*, Paris, 1963

Salvador Dalí, *Diary of a Genius*, New York, 1965

Manifeste en hommage à Meissonier, exhibition catalogue, Hotel Meurice, Paris, 1967

Alain Bosquet, *Conversations with Dalí*, New York, 1969

Dalí, exhibition catalogue, Museum Boymans-van Beuningen, Rotterdam, 1970–1

Robert Descharnes, *The World of Salvador Dalí*, 2nd edition, New York, 1972

A Reynolds Morse, *Salvador Dalí: A Guide to his Works in Public Collections*, Cleveland, OH, 1973

Luis Romero, *Salvador Dalí*, Secaucus, NJ, 1975

Salvador Dalí, *The Unspeakable Confessions of Salvador Dalí*, London, 1976

Salvador Dalí: Retrospective, 1920–80, exhibition catalogue, Musée National d'Art Moderne, Centre Georges Pompidou, Paris, 1979–80

Salvador Dalí, exhibition catalogue, Tate Gallery, London, 1980

400 obras de Salvador Dalí de 1914 a 1983, exhibition catalogue, Museo Español de Arte Contemporaneo, Madrid and Palau Reial de Pedralbes, Barcelona, 1983

Robert Descharnes, *Salvador Dalí: The Work the Man*, New York, 1984

Amanda Lear, *My Life with Dalí*, London, 1985

Merle Secrest, *Salvador Dalí: The Surrealist Jester*, London, 1986

Dawn Ades, *Dalí*, 2nd edition, London, 1988

Salvador Dalí, 1904–89, exhibition catalogue, Staatsgalerie, Stuttgart and Kunsthaus, Zurich, 1989

A Reynolds Morse and Robert S Lubar (eds.), *Dalí: The Salvador Dalí Museum Collection*, Boston, New York, London and Toronto, 1991

Salvador Dalí and Philippe Halsman, *Dalí's Mustache: A Photographic Interview*, 2nd edition, Paris, 1994

Salvador Dalí: The Early Years, exhibition catalogue, Hayward Gallery, London; Metropolitan Museum of Art, New York; Museo Nacional Centro de Arte Reina Sofia, Madrid; Palau Robert, Barcelona, 1994–5

List of Illustrations

Colour Plates

21 Gala and *The Angelus* of Millet before the
 Imminent Arrival of the Conical
 Anamorphoses
 1933. Oil on panel, 24 x 18.8 cm.
 National Gallery of Canada, Ottawa

22 Phantom Waggon
 1933. Oil on canvas, 16 x 20.3 cm.
 Yale University Art Gallery,
 New Haven, CT

23 The Spectre of Sex Appeal
 1934. Oil on canvas, 18 x 14 cm.
 Fundacio Gala-Salvador Dalí, Figueras

24 Portrait of Gala
 1935. Oil on canvas, 32.4 x 26.7 cm.
 Museum of Modern Art, New York

25 Mae West's Lips Sofa
 1936–7. Wooden frame covered with pink
 satin, h86 cm.
 Private collection, on loan to the Victoria
 and Albert Museum, London

26 Lobster Telephone
 1936. Steel, plaster, rubber, resin and
 paper, h30 cm.
 Tate Gallery, London

27 Suburbs of the Paranoiac-critical City:
 Afternoon on the Fringes of European
 History
 1936. Oil on wood, 46 x 66 cm.
 Private collection

28 Soft Construction with Boiled Beans:
 Premonition of Civil War
 1936. Oil on canvas, 110 x 84 cm.
 Museum of Art, Philadelphia, PA

29 Autumn Cannibalism
 1936. Oil on canvas, 65 x 65.2 cm.
 Tate Gallery, London

30 The Metamorphosis of Narcissus
 1937. Oil on canvas, 50.8 x 78.2 cm.
 Tate Gallery, London

31 Sleep
 1937. Oil on canvas, 51 x 78 cm.
 Private collection

32 Impressions of Africa
 1938. Oil on canvas, 91.5 x 117.5 cm.
 Museum Boymans-van Beuningen,
 Rotterdam

33 Mountain Lake.
 1938. Oil on canvas, 73 x 92 cm.
 Tate Gallery, London

34 Spain
 1938. Oil on canvas, 91.8 x 60.2 cm.
 Museum Boymans-van Beuningen,
 Rotterdam

35 Slave Market with the Disappearing
 Bust of Voltaire
 1940. Oil on canvas, 46.5 x 65.5 cm.
 Salvador Dalí Museum, St Petersburg, FL

36 Dream Caused by the Flight of a Bee
 around a Pomegranate One Second before
 Awakening
 1944. Oil on canvas, 51 x 41 cm.
 Fundación Colección Thyssen-
 Bornemisza, Madrid

37 Portrait of Frau Isabel Styler-Tas
 1945. Oil on canvas, 65.5 x 86 cm.
 Staatliche Museen Preussischer
 Kulturbesitz Nationalgalerie, Berlin

38 The Temptation of St Anthony
 1946. Oil on canvas, 89.7 x 119.5 cm.
 Musées Royaux des Beaux-Arts de
 Belgique, Brussels

39 The First Study for the Madonna of
 Port Lligat
 1949. Oil on canvas, 48.9 x 37.5 cm.
 The Patrick and Beatrice Haggerty
 Museum of Art, Marquette University
 Milwaukee, WI

40 Christ of St John of the Cross
 1951. Oil on canvas, 205 x 116 cm.
 St Mungo Museum of Religious Life and Art,
 Glasgow

41 The Disintegration of the Persistence
 of Memory
 1952–4. Oil on canvas, 10 x 13 cm.
 Private collection, on loan to the Salvador
 Dalí Museum, St Petersburg, FL

42 Crucifixion or Corpus Hypercubicus
 1954. Oil on canvas, 194.5 x 124 cm.
 Metropolitan Museum of Art, New York

43 The Sacrament of the Last Supper
 1955. Oil on canvas, 167 x 268 cm.
 National Gallery of Art, Washington DC

44 Still Life – Fast Moving
 1956. Oil on canvas, 125.7 x 160 cm.
 Salvador Dalí Museum, St Petersburg, FL

45 Velázquez Painting the Infanta Margarita
 with the Lights and Shadows of his own
 Glory
 1958. Oil on canvas, 153 x 92 cm.
 Private collection, on loan to the Salvador Dalí
 Museum, St Petersburg, FL

46 The Discovery of America by Christopher
 Columbus
 1958–9. Oil on canvas, 410 x 310 cm.
 Salvador Dalí Museum, St Petersburg, FL

47 Tuna Fishing (Homage to Meissonier)
 1966–7. Oil on canvas, 400 x 300 cm.
 Private collection

48 Hallucinogenic Toreador
 1969–70. Oil on canvas, 400 x 300 cm.
 Salvador Dalí Museum, St Petersburg, FL

Text Illustrations

1 The Artist's Father and Sister
 1925. Pencil on paper, 49 x 33 cm. Museu
 d'Art de Catalunya, Barcelona

2 Purist Still Life
 1924. Oil on canvas, 100 x 100 cm.
 Fundacio Gala-Salvador Dalí, Figueras

3 Basket of Bread
 1926. Oil on panel, 31.5 x 32 cm.
 Salvador Dalí Museum, St Petersburg, FL

4 Portrait of Federico García Lorca
 c1923. Oil on cardboard, 74.6 x 52 cm.
 Fundacio Gala-Salvador Dalí, Figueras

5 From left to right: Salvador Dalí, Luis
 Buñuel, Simone Mareuil (actress), Jeanne
 Rucas (Mme Buñuel), Pierre Batcheff
 (actor) on the set of the film *Un Chien
 andalou*
 1929. Photograph

6 Lya Lys and a statue
 1930. Still from the film *L'Age d'or*

7 Dismal Sport
 1929. Oil and collage on canvas,
 31 x 41 cm. Private collection

8 The Accommodations of Desires
 1929. Oil and collage on board, 22 x 35 cm.
 Private collection

9 The Sacred Heart
 1929. Ink on canvas, 68.3 x 50.1 cm.
 Musée National d'Art Moderne,
 Centre Georges Pompidou, Paris

10 William Tell
 1930. Oil and collage on canvas,
 113 x 87 cm. Private collection

11 Invisible Sleeping Woman, Horse,
 Lion etc.
 1930. Oil on canvas, 50.2 x 65.2 cm.
 Musée National d'Art Moderne,
 Centre Georges Pompidou, Paris

12 Swans Reflecting Elephants
 1937. Oil on canvas, 51 x 77 cm.
 Private collection

13 Corpuscular Madonna
 1952. Pencil, sepia and indian ink on paper,
 55.6 x 43.2 cm.
 Museum of Art, Birmingham, AL

14 'Me Crazy? I am certainly saner than the
 person who bought this book.'
 1954. Photograph of Dalí from *Dalí's Mustache: A
 Photographic Interview*

15 Perpignan Station
 1965. Oil on canvas, 295 x 406 cm.
 Ludwig Museum, Cologne

16 Holos! Holos! Velázquez Gabor
 1972–3. Hologram, 42 x 57 cm.
 Fundacio Gala-Salvador Dalí, Figueras

17 Cybernetic Princess
 1974. Computer circuits and
 components, length 2m.
 Fundacio Gala-Salvador Dalí, Figueras

Comparative Figures

18 GEORGES BRAQUE
The Emigrant
1911–12. Oil on canvas, 116.7 x 81.5 cm.
Kunstmuseum, Basle

19 Portrait of Ana Maria (Cadaqués)
c1925. Oil on canvas, 92 x 65 cm.
Fundacio Gala-Salvador Dalí, Figueras

20 PABLO PICASSO
Studio with Plaster Head
1925. Oil on canvas, 98.1 x 131.1 cm.
Museum of Modern Art, New York

21 Putrefying Donkeys and Pianos
1929. Still from the film Un Chien andalou

22 JEAN ARP
Mountain, Table, Anchors, Navel
1925. Oil on cardboard with cutouts,
75.2 x 59.7 cm.
Museum of Modern Art, New York

23 MAX ERNST
Pietà or Revolution by Night
1923. Oil on canvas, 114 x 88 cm.
Tate Gallery, London

24 The Birth of Liquid Desires
1932. Oil on canvas, 122 x 95 cm.
Fondazione Peggy Guggenheim, Venice

25 The Nostalgia of the Cannibal
1932. Oil on canvas, 47.2 x 47.2 cm.
Sprengel Museum, Hanover

26 JEAN-FRANÇOIS MILLET
The Angelus
1858–9. Oil on canvas, 55 x 66 cm.
Musée d'Orsay, Paris

27 Paranoiac-astral Image
1935. Oil on wood, 16 x 21.8 cm.
Wadsworth Atheneum, Hartford, CT

28 The Face of Mae West
1934–5. Gouache on newspaper,
31 x 17 cm. Art Institute, Chicago, IL

29 Minotaure
1936. Cover of the journal Minotaure, No. 8

30 GEORGE PLATT LYNES
Dalí, a Model and a Lobster
1939. Photograph made for the Dream of
Venus for the International World Fair in
New York

31 The Enigma of Hitler
1937. Oil on panel, 94 x 141 cm.
Private collection

32 The Great Paranoiac
1936. Oil on canvas, 62 x 62 cm.
Museum Boymans-van Beuningen,
Rotterdam

33 Apotheosis of Homer
1945. Oil on canvas, 63.5 x 117 cm.
Staatsgalerie Moderner Kunst, Munich

34 PIERO DELLA FRANCESCA
Portrait of Federigo da Montefeltro and
Battista Sforza
c1465. Panel, each 47 x 33 cm.
Galleria degli Uffizi, Florence

35 ST JOHN OF THE CROSS
The Crucifixion
C16th. Drawing, dimensions unknown.
Monastero de la Incarnación, Avila

36 DIEGO VELAZQUEZ
The Infanta
1660. Oil on canvas, 127.5 x 107.5 cm.
Museo Nacional del Prado, Madrid

37 Santiago el Grande
1957. Oil on canvas, 400 x 300 cm.
Beaverbrook Art Gallery, Fredericton, NB

1

Self-portrait with Raphaelesque Neck

1921–2. Oil on canvas, 41.5 x 53 cm. Fundacio Gala-Salvador Dalí, Figueras

Throughout his career Dalí was to represent himself in many guises, most memorably as the disembodied rock-like head of his Surrealist period (see Plate 15). This early painting, however, exemplifies the artist's attempts in the traditional genre of self-portraiture. Dalí's haughty elegance is emphasized by the elongated neck, which the painting's title describes inaccurately as 'Raphaelesque', in other words in a High Renaissance style. In fact its distortion owes more to later Italian paintings, such as the famous *Madonna with a Long Neck* (Galleria degli Uffizi, Florence) by the Mannerist artist Francesco Parmigianino (1503–40). Despite Dalí's reference to foreign works which he could only have known through reproductions, the self-portrait draws heavily on more local inspiration. The painting's background depicts the coastline around Cadaqués on the Costa Brava, where Dalí's family spent their summers. One of the occasional inhabitants of Cadaqués was Ramon Pichot, a family friend and successful painter whose influence is obvious in this painting, in particular in its heavy use of the colours orange and violet, colours particularly favoured by Pichot.

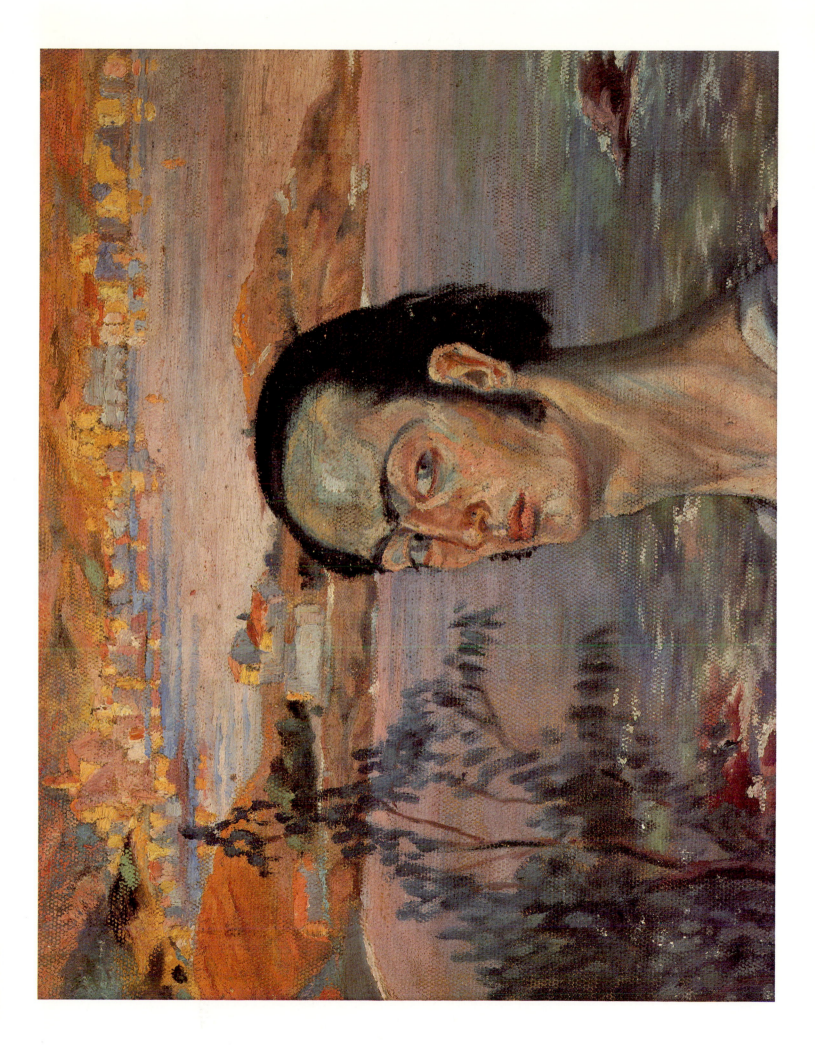

Self-portrait with *La Publicitat*

1923. Gouache on cardboard, 105 x 75 cm. Museo Nacional Centro de Arte Reina Sofia, Madrid

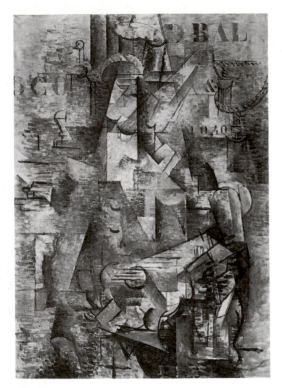

Fig. 18
GEORGES BRAQUE
The Emigrant
1911–12. Oil on canvas,
116.7 x 81.5 cm.
Kunstmuseum, Basle

In this work only Dalí's black hair identifies him with the subject of his earlier self-portrait (see Plate 1). The painting demonstrates Dalí's recent discovery of Cubism through publications obtained for him by relations and family friends. While some of his other Cubist efforts were to reflect recent developments in France, this work is obviously based on the portraits that Braque and Picasso made over a decade earlier (see Fig. 18), although the structure of Dalí's painting is much simpler and less subtle than that of its predecessors. The reference to the Barcelona newspaper *La Publicitat* emphasizes the fact that Dalí was still a provincial artist, far removed from the avant-garde in Paris.

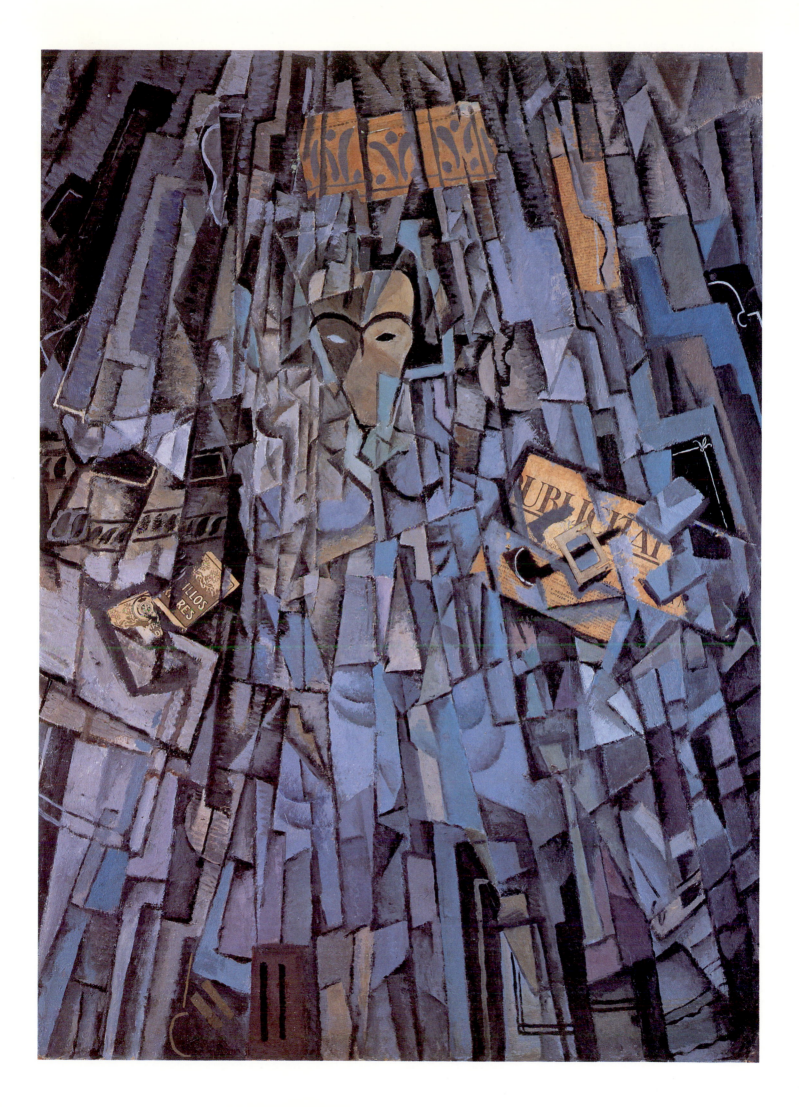

3

Cadaqués

1923. Oil on canvas, 100 x 98 cm. Fundacio Gala-Salvador Dalí, Figueras

The area around the fishing village of Cadaqués exercised a profound influence on the artist throughout his life. As Dalí later wrote: 'I made myself on these shores, created my persona here, discovered my love, painted my œuvre, built my house.' In 1923, with these developments still in the future, Dalí created this panorama of the village, which recalls the paintings that Picasso and André Derain (1880–1954) had made at Cadaqués in the 1910s. The opaque sky and crowded cube-shaped houses give the work a strong tactile quality, while the figures in the foreground, in particular the woman scratching her leg, prevent it from merely being a dry Cubist landscape. Nonetheless, it was only later that Dalí managed to produce a more individual response to the sights and experiences of the area (see Plate 19).

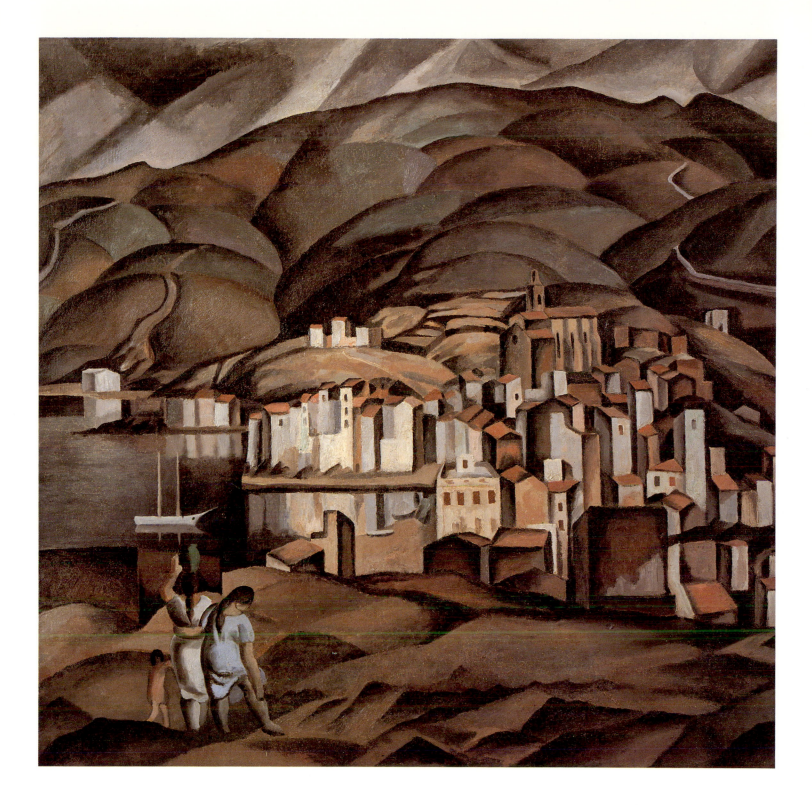

4 Venus and Sailor (Homage to
Salvat-Papasseit)

1925. Oil on canvas, 216 x 147 cm. Ikeda Museum of 20th-century Art, Sizuoka-Ken

This painting was given the subtitle 'Homage to Salvat-Papasseit' in memory of a recently deceased Catalan poet. It might just as well have been called 'Homage to Picasso'. The skill with which Picasso switched from style to style in this period, even sometimes within the same painting, is reflected in this work, in which a sailor, constructed from flat Cubist planes and stripped of all personal attributes apart from his pipe, clasps a strongly modelled woman of formidable bulk. Just as in works by Picasso, her posture, dress, hair and ample proportions display a deliberately distorted form of classicism: even the reference in the painting's title to Venus is ironic in the context of what is in fact a brothel scene.

Dalí himself acknowledged the extent of his debt to Picasso. In *The Unspeakable Confessions of Salvador Dalí* he recorded that 'Picasso is doubtless the man I have most often thought about after my father.' In the cases of both his father and Picasso, Dalí's early adulation unfortunately soon turned into a sense of rivalry and contempt, but it is undeniable that Picasso's initial influence was crucial to his artistic development.

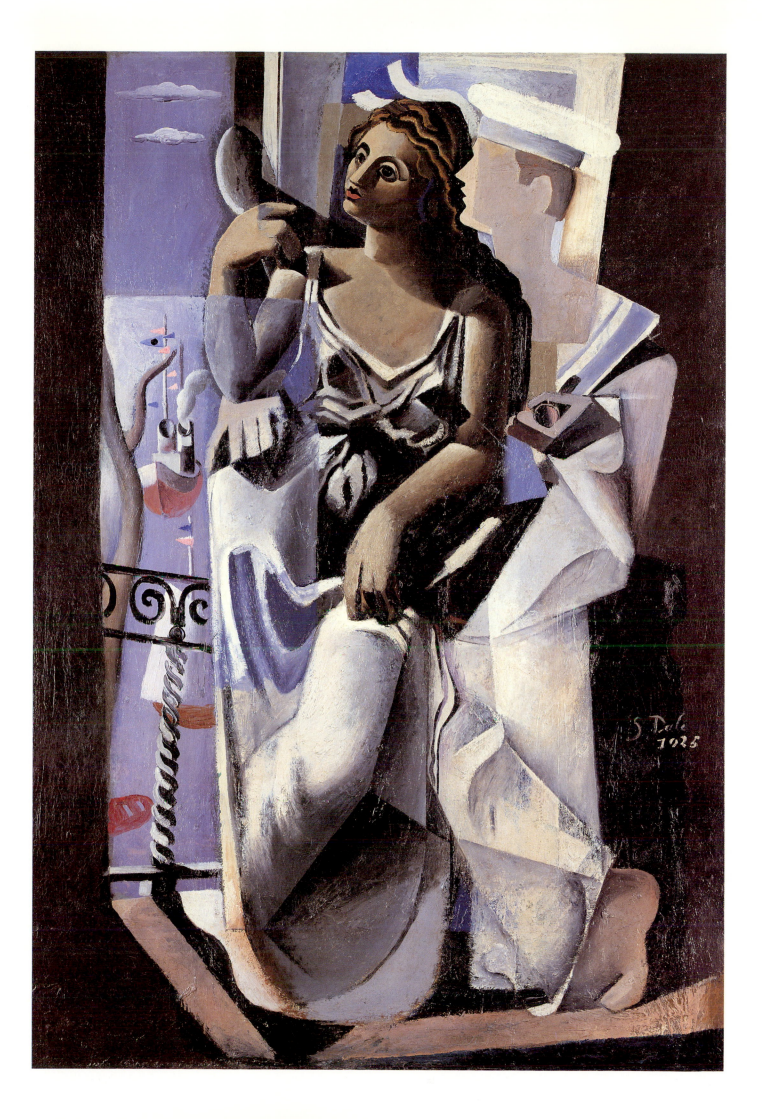

Figure at a Window

1925. Oil on canvas, 102 x 75 cm. Museo Nacional Centro de Arte Reina Sofia, Madrid

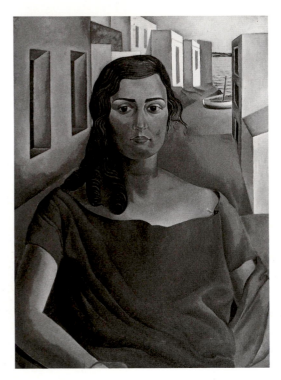

This beautiful painting belongs to a series of works depicting Dalí's sister Ana Maria, all executed between 1923 and 1926 (see Fig. 19). Ana Maria, who was 17 in 1925, is shown gazing out at the sea at Cadaqués. This picture exemplifies Dalí's self-confessed enthusiasm for women's backs, and it is unusual in its serenity and classical harmony. Nonetheless, even such an apparently unthreatening work has an uneasy feel to it; Dalí has strangely omitted to paint the left side of the window. While this is presumably a deliberate irregularity, the overlap between the girl's left foot and the bottom of the wall appears to be a mistake, perhaps bearing out Dalí's admission that even despised academic artists such as William Adolphe Bouguereau (1825–1905) and Jean Louis Ernest Meissonier (1815–91) could, in terms of technique, paint 'a thousand times better than I can'.

Fig. 19
Portrait of Ana Maria
(Cadaqués)
*c*1925. Oil on canvas,
92 x 65 cm.
Fundacio Gala-Salvador
Dalí, Figueras

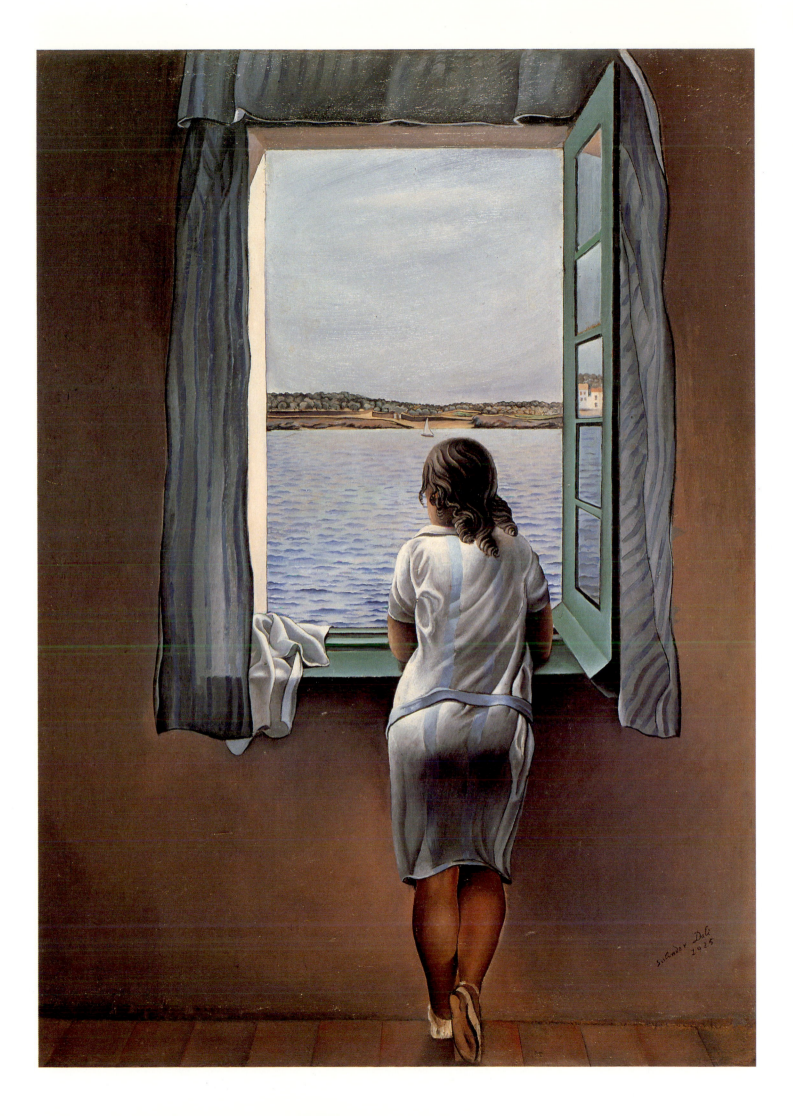

Seated Girl Seen from the Back

1925. Oil on canvas, 104 x 74 cm. Museo Nacional Centro de Arte Reina Sofia, Madrid

Like *Figure at a Window* (Plate 5) this portrait of Ana Maria was shown in 1925 at Dalí's first one-man exhibition at the Dalmau Gallery in Barcelona, which attracted the attention of Picasso and Miró. Although in both paintings the concealment of Ana Maria's face adds greatly to the work's enigmatic quality, the two compositions are in fact quite different. *Figure at a Window* is dominated by empty space, and the viewer is distanced from both the girl and the landscape outside, which is framed by the window as if it was a picture within a picture. In *Seated Girl Seen from the Back* on the other hand, Ana Maria is shown sitting outside, close to the viewer. Moreover the sensuality of the scene is enhanced by the beautiful folds of her dress, one of the best examples of Dalí's mastery of academic techniques.

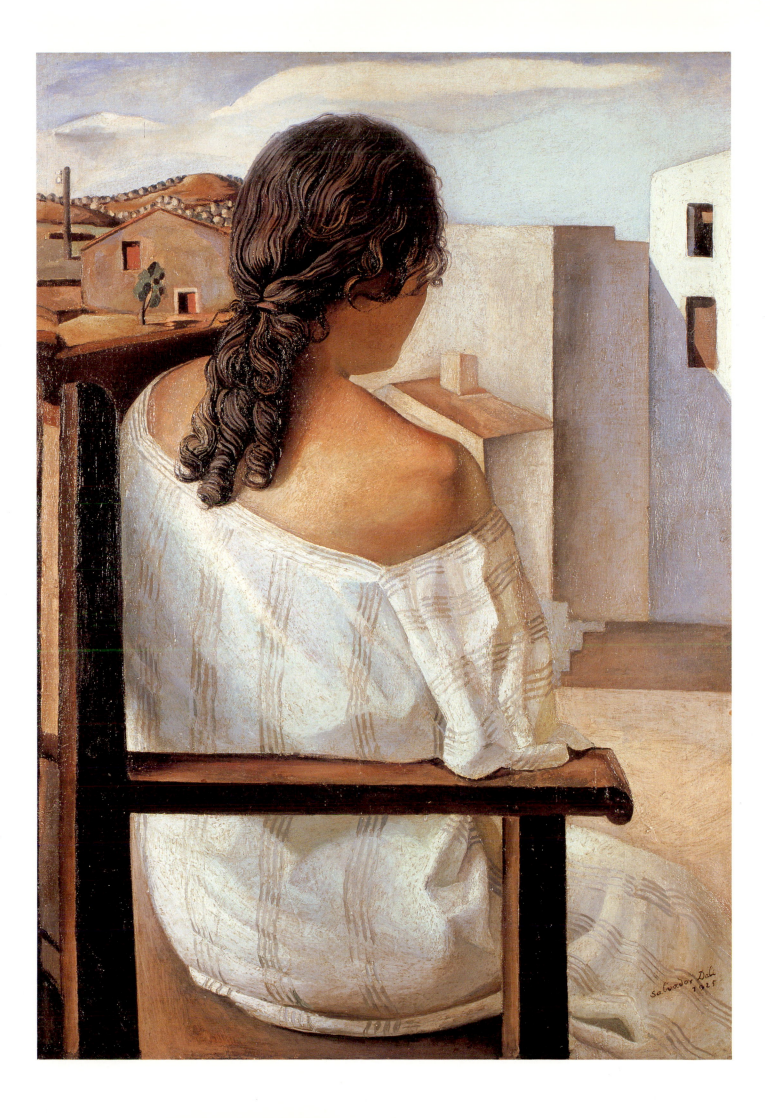

Figure on the Rocks

1926. Oil on panel, 27.5 x 45 cm. Salvador Dalí Museum, St Petersburg, FL

Following his visit to Paris in 1926, when he met Picasso for the first time, Dalí returned home and produced this somewhat disturbing painting, which was exhibited in Barcelona in the autumn of that year. The rocks in question are those of his beloved Costa Brava, which he also represented elsewhere in less threatening guise in *Cliffs (Woman on the Rocks)*, also of 1926, (Private collection). The woman stretched out on the rocks is again Ana Maria, whose features can be identified in the shadow of the profile cast onto her arm. However, Dalí has metamorphosized his sister into a monumental female figure in the style of Picasso. The power of this image is greatly enhanced by its violent foreshortening, which anticipates the spectacular effects that Dalí was to achieve much later in such paintings as *Christ of St John of the Cross* (Plate 40).

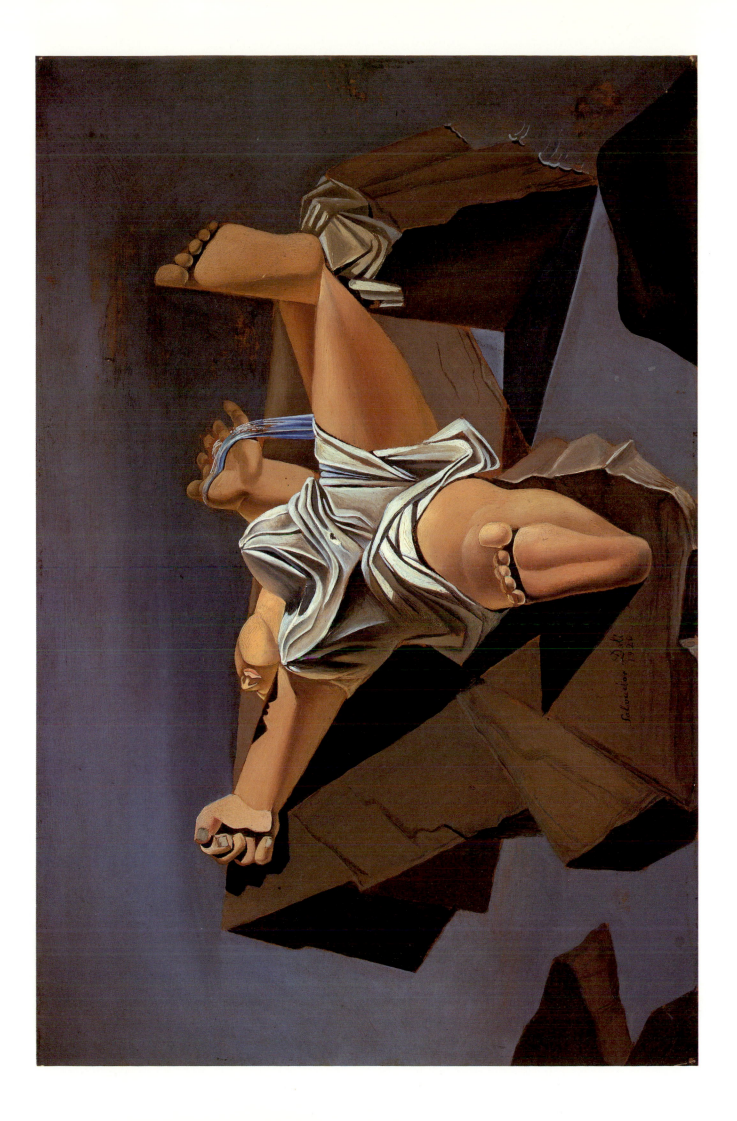

Still Life by Moonlight

1926. Oil on canvas, 199 x 150 cm. Museo Nacional Centro de Arte Reina Sofia, Madrid

Although this painting is Cubist in style, its imagery has a strong poetic and surreal quality. Picasso was already exhibiting this combination of apparently contradictory elements in his work. However, while the bust lying on the table in Dalí's work recalls Picasso's *Studio with Plaster Head* (Fig. 20), images such as the guitar, whose neck uncannily resembles the bodies of the fish lying next to it, are Dalí's own inventions. Indeed he later identified the flaccid guitar as a precursor of the famous soft watches of *The Persistence of Memory* (Plate 19). While most of *Still Life by Moonlight* is in appropriately nocturnal tones, the expressiveness of the scene is enhanced by the occasional use of bright colours, especially in the remarkable blue fish, which Dalí has endowed with unexpectedly vivacious features.

Fig. 20
PABLO PICASSO
Studio with Plaster
Head
1925. Oil on canvas,
98.1 x 131.1 cm.
Museum of Modern Art,
New York

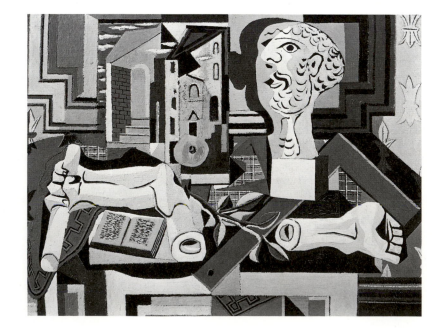

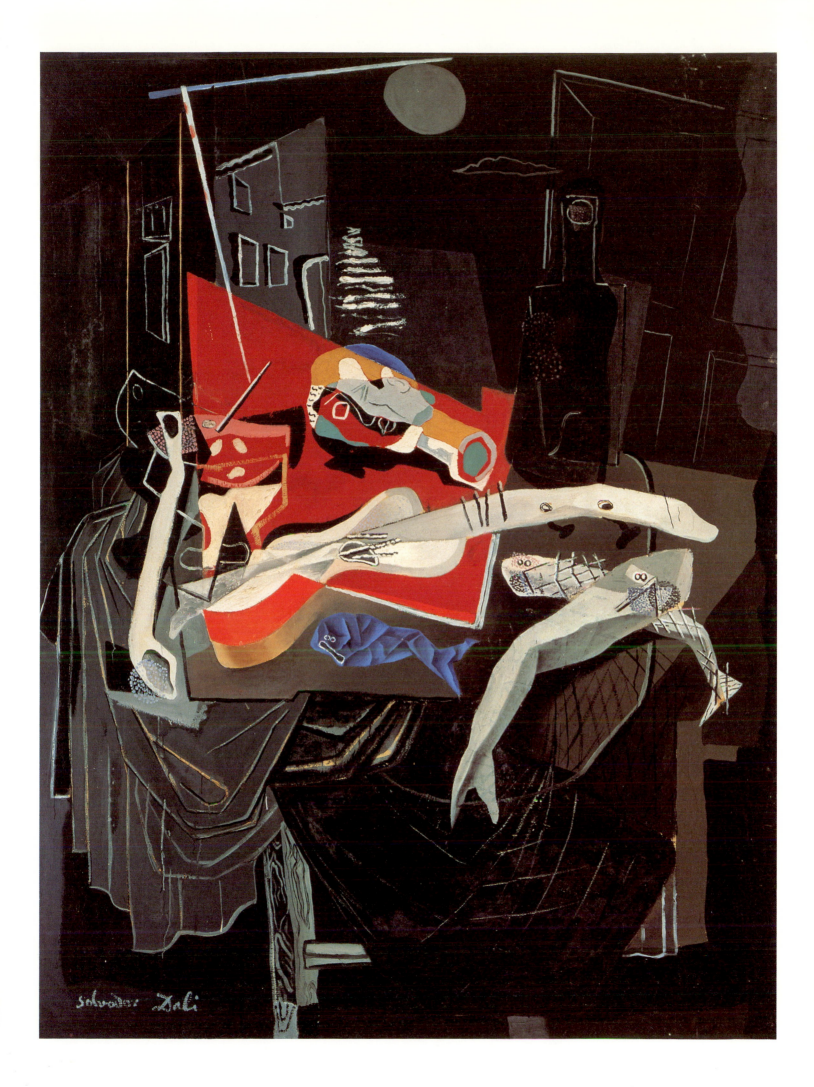

Apparatus and Hand

1927. Oil on panel, 62 x 47.5 cm. Salvador Dalí Museum, St Petersburg, FL

During 1927 Dalí began to absorb new influences, while also developing a more individual pictorial language. The 'apparatus' in this painting, at once both geometric and vaguely human in form, has specific precedents in the work of the French Surrealist Tanguy and the Italian painter Giorgio de Chirico (1888–1978), whose early work was much admired by the Surrealists. Nonetheless, Dalí was at this time still keen to maintain his independence from Surrealism. While *Apparatus and Hand* does undeniably draw on Surrealist imagery, it also includes more personal motifs, such as the putrefying donkey in the bottom left, which reappears in *Little Ashes* (Plate 10) and also features in *Un Chien andalou*, the film he made with Buñuel (see Fig. 21). The reference to death and decay is complemented by the presence of the disembodied hand on top of the apparatus; blood-red and blue-veined, this looks as if it has been flayed. The violence of this image introduces a new tone to Dalí's work, which was to become still more marked in the following years.

It is perhaps not surprising that such imagery provoked a negative response from conservative critics. Dalí replied by claiming that his 'anti-artistic' work was perfectly understood by children and the fishermen of Cadaqués: only a 'sophisticated' viewer, seeing the world through conventional stereotypes, would fail to understand his own fresh vision of reality.

Fig. 21
Putrefying Donkeys
and Pianos
1929. Still from the film
Un Chien andalou

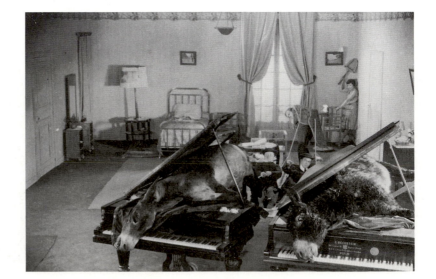

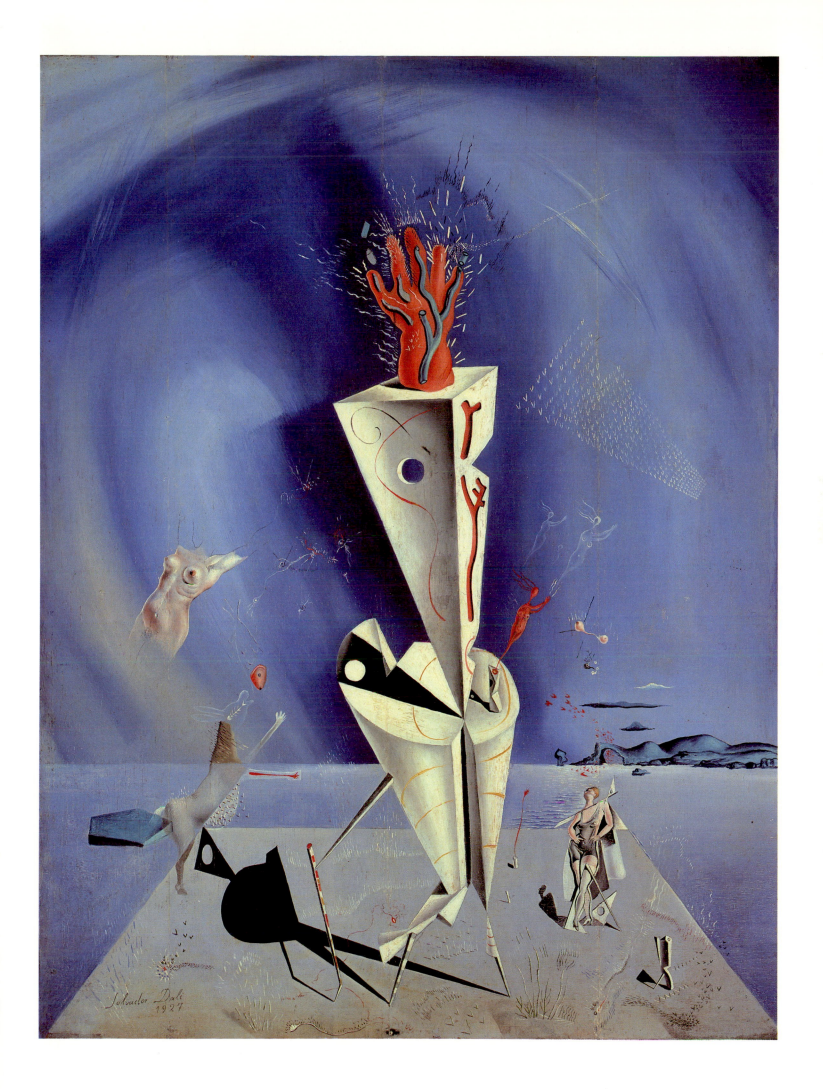

Little Ashes

1928. Oil on panel, 64 x 48 cm. Museo Nacional Centro de Arte Reina Sofia, Madrid

The sleeping head of Dalí is the key to understanding this enigmatic work. The image of the artist suggests that the other bizarre objects which fill this painting express his own dreams and subconscious desires. Although the painting's ambiguous sexual and schatological forms show the influence of Miró, an early supporter of Dalí, many of the motifs, such as the skeletal donkey, testify to Dalí's own highly individual imagination. The giant floating torso, of ambiguous gender, is particularly striking; it has apparently been captured in the process of metamorphosizing into another form covered with thick red and yellow bristles. While Dalí was still attempting to preserve his detachment from Surrealism at this time, *Little Ashes* looks forward to his first mature Surrealist paintings of 1929.

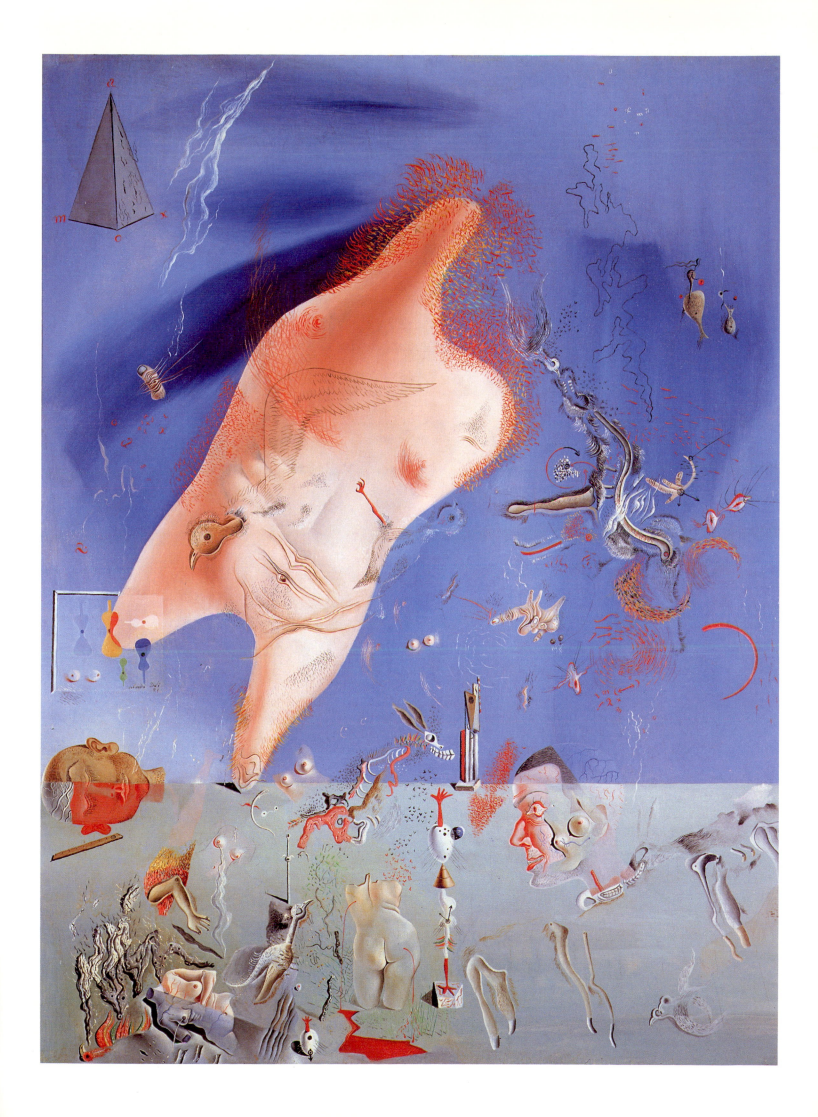

11 The Spectral Cow

1928. Oil on panel, 50 x 64.5 cm. Musée National d'Art Moderne, Centre Georges Pompidou, Paris

In 1923 Breton, who was soon to become the leader of the Surrealist movement, wrote *Clair de terre*, in which he describes how he dreamed of the shooting of a bird flying over a beach. Breton relates how when the creature fell into the sea he discovered to his surprise it was in fact not a bird at all, but some other kind of animal – a cow or a horse. This odd story must have impressed Dalí at least, since both the phantom bird and cow reappear in this painting, which is also obviously inspired by *The Beautiful Season* of 1925 (Private collection) by the German Surrealist Ernst. However, *The Spectral Cow* also refers to some of Dalí's own favourite imagery: the skeletal bodies, for example, are clearly related to the rotting donkeys that feature so often in his other works. Meanwhile, as in *Little Ashes* (Plate 10) a small pyramid floats mysteriously in the upper part of the painting, its geometric perfection contrasting with the scene of organic decay beneath.

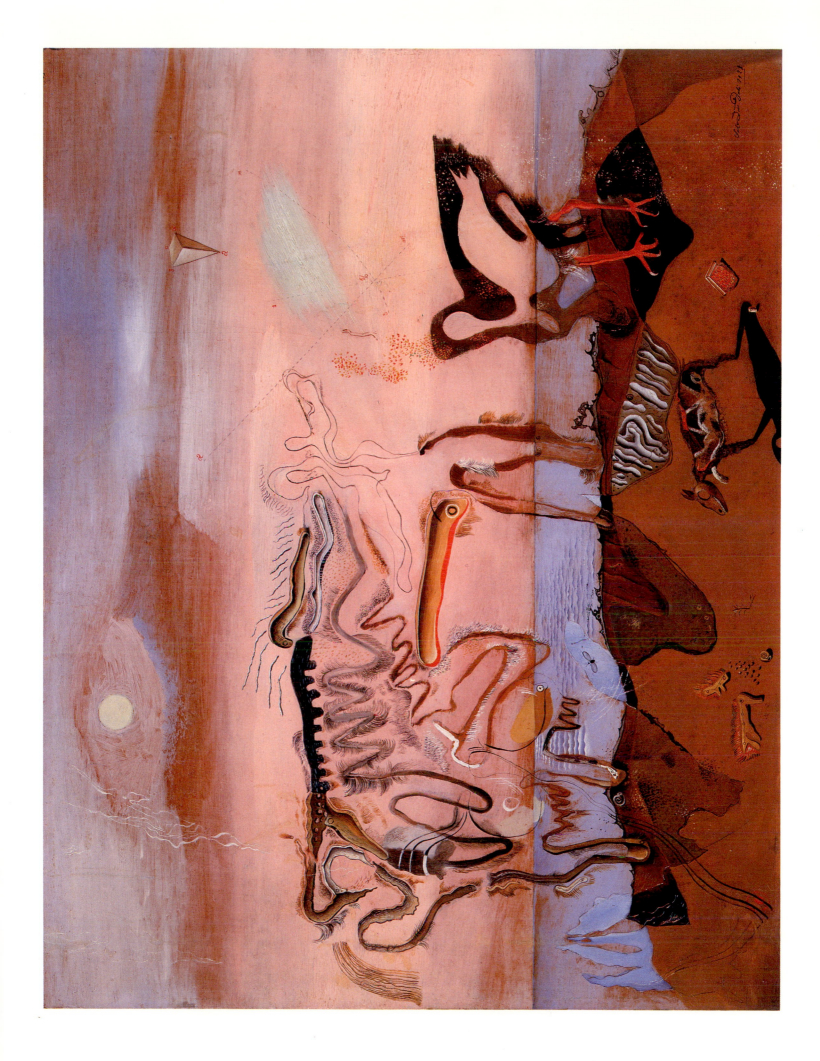

1928. Oil on canvas, 148 x 196 cm. Museo Nacional Centro de Arte Reina Sofia, Madrid

Fig. 22
JEAN ARP
Mountain, Table,
Anchors, Navel
1925. Oil on cardboard
with cutouts, 75.2 x 59.7 cm.
Museum of Modern Art,
New York

Another Surrealist who influenced Dalí was the French artist Jean Arp (1887–1966), whose highly abstracted forms lent themselves particularly well to alternative interpretations (see Fig. 22). This ambiguity, which is imitated in this painting, was highly attractive to Dalí, even though he was in general implacably opposed to Abstract art. Although a few other of Dalí's works at this time also reflect Arp's biomorphic forms, soon afterwards his own radically different Surrealist style finally crystallized.

13 The First Days of Spring

1929. Oil and collage on panel, 50 x 65 cm. Private collection, on loan to the Salvador Dalí Museum, St Petersburg, FL

After making *Un Chien andalou* with Buñuel in the spring of 1929, Dalí produced a series of extraordinary paintings which were exhibited in Paris at the Goemans Gallery in the following November. The first of these works, appropriately entitled *The First Days of Spring*, demonstrates Dalí's increasing enthusiasm for Freudian psychoanalysis, in which even the staircase is given a definite sexual significance. Other motifs relate to early experiences that Dalí describes in his own writings. In the article 'The Liberation of the Fingers', published in *The Friend of the Arts* in March 1929, Dalí relates how as a child he picked up a small fish outside his parents' house in Cadaqués and to his horror saw a resemblence between the animal's face and that of a grasshopper. The strength of this trauma is reflected by the appearance in this work of both the fish and the insect, which is shown attached to the mouth of Dalí's disembodied head. At this time Dalí also became preoccupied with his relationship with his father, who appears twice in this work: the two tiny figures in the background are almost certainly the infant Dalí and his father, who is also depicted on the right of the painting in conversation with Dalí's sister Ana Maria.

The most remarkable technical feature of *The First Days of Spring* is its use of collage. While the black and white photograph of the infant Dalí is easily identifiable in the centre of the composition, it is extremely difficult to distinguish the various coloured images that Dalí has pasted onto the work, a fact that was noted by the Surrealist writer Louis Aragon when he included *The First Days of Spring* in an exhibition of collages that he organized in 1930. As well as playing a game with the viewer's perception, the deliberate confusion between collage and painting also exemplifies Dalí's conviction that, as he later put it, painting should be a form of 'hand-done colour photography of the...images of concrete irrationality'.

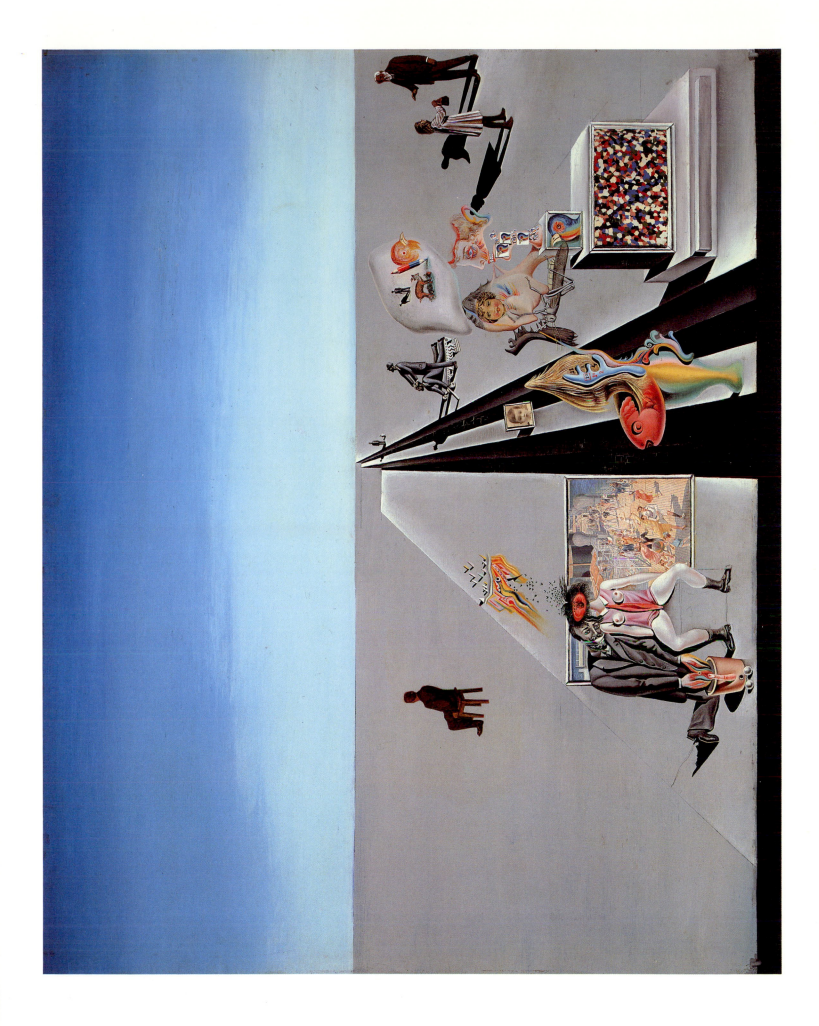

1929. Oil and collage on board, 23.8 x 34.7 cm. Museum of Modern Art, New York

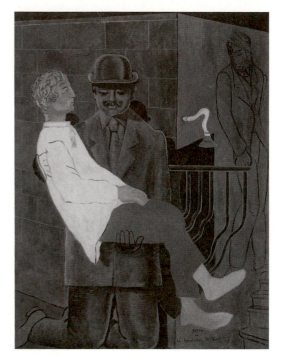

Fig. 23
MAX ERNST
Pietà or Revolution
by Night
1923. Oil on canvas,
114 x 88 cm.
Tate Gallery, London

In contrast to *The First Days of Spring* (Plate 13), which contains large areas of empty space, *Illumined Pleasures* is a claustrophobic assemblage of paintings within a painting, in which Dalí has crammed various disquieting scenes. The conceit of a picture containing other pictures was not entirely original, and in this case the device is particularly indebted to the earlier work of De Chirico. However, much of the accompanying imagery was unique to Dalí. Some elements of the composition, such as Dalí's recumbent head and the grasshopper, are already familiar from *The First Days of Spring* (Plate 13). In *Illumined Pleasures* Dalí has surrounded these images with references to parental violence and masturbation, one of his own greatest pleasures. The latter activity is suggested by the repetitious nature of the serial image of a cyclist, which suggestively conceals the lower body of a young man who turns away in shame. A more complex chain of associations is suggested by the figures of a man and woman in the foreground of the painting. The male undoubtedly resembles the father in Ernst's *Pietà or Revolution by Night* (Fig. 23), a famous Surrealist image that refers not only to the Passion of Christ but also to the legend of Oedipus, whose father attempted to kill him when he was a baby. In Dalí's painting the bearded man holds not his son but a woman, who has been associated with Venus, the goddess who was born fully grown out of the ocean. Another identification, with Lady Macbeth, is perhaps more likely, since the woman's bloodstained hands are certainly linked to the dagger in the corner of the painting. Whatever the woman's identity, Dalí's mysterious allusions to legendary stories undoubtedly demonstrate the influence of Freud, for whom myths could symbolize otherwise repressed desires and fears.

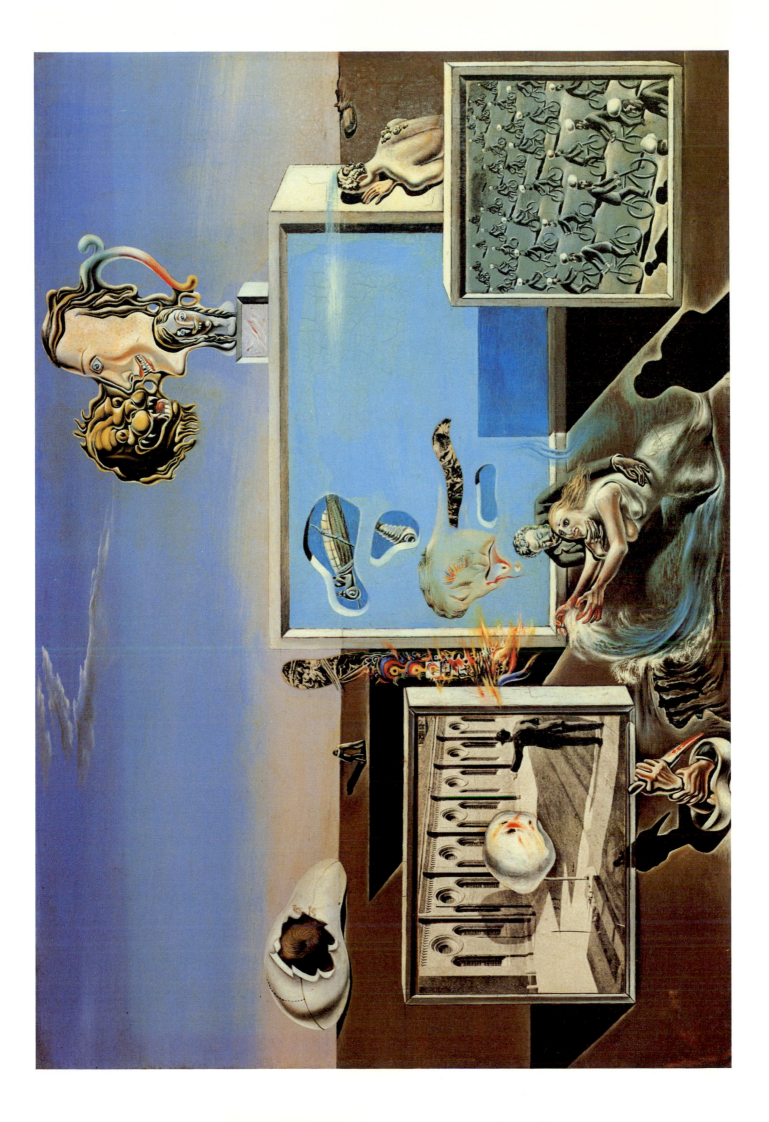

The Great Masturbator

1929. Oil on canvas, 110 x 150.5 cm. Museo Nacional Centro de Arte Reina Sofia, Madrid

Dalí's guilty preoccupation with masturbation was inextricably linked with his fear of punishment by emasculation. In *The Great Masturbator* the threat of mutilation is only hinted at through the cuts in the knees of the male figure on the right. By far the most striking quality of the painting is its concentration on complex visual analogies, which anticipates the so-called paranoia-criticism of his work of the 1930s. The most obvious example of this is the way in which Dalí has transformed the image of his head into a great boulder with the bizarre form of the rocks of his beloved Costa Brava. Its precariousness is emphasized by the pile of objects, topped by an egg, which is delicately balanced on top of it. The rock's most remarkable features are its bright yellow colour and apparent softness, expressive qualities that are also developed, to memorable effect, in *The Birth of Liquid Desires* (Fig. 24).

The fluidity of the rock is particularly apparent in the bottom right-hand corner, where it suddenly changes into a strange piece of sinuous Art Nouveau decoration. Dalí frequently expressed his feeling for Art Nouveau buildings, which he described as the 'true realizations of solidified desires', and maintained that the architecture of the Catalan Antonio Gaudi (1852–1926) had, like his own work, been inspired by the rock formations of the Costa Brava. Dalí's passion for the art of this period also extended to figurative works. As he recorded, in this painting the long-haired woman with an obviously phallic lily was taken from a late nineteenth-century lithograph. The ease with which the image of Dalí's head metamorphosizes into these other forms distinguishes *The Great Masturbator* from contemporary paintings such as *Illumined Pleasures* (Plate 14). Soon afterwards, however, his painting underwent an even more significant transformation.

Fig. 24
The Birth of Liquid
Desires
1932. Oil on canvas,
122 x 95 cm.
Fondazione Peggy
Guggenheim, Venice

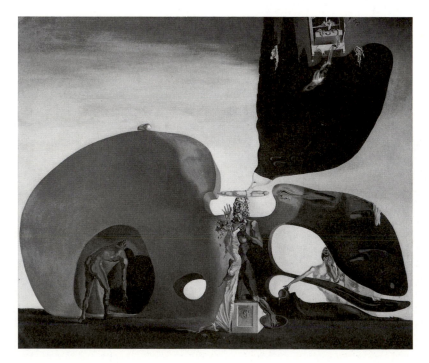

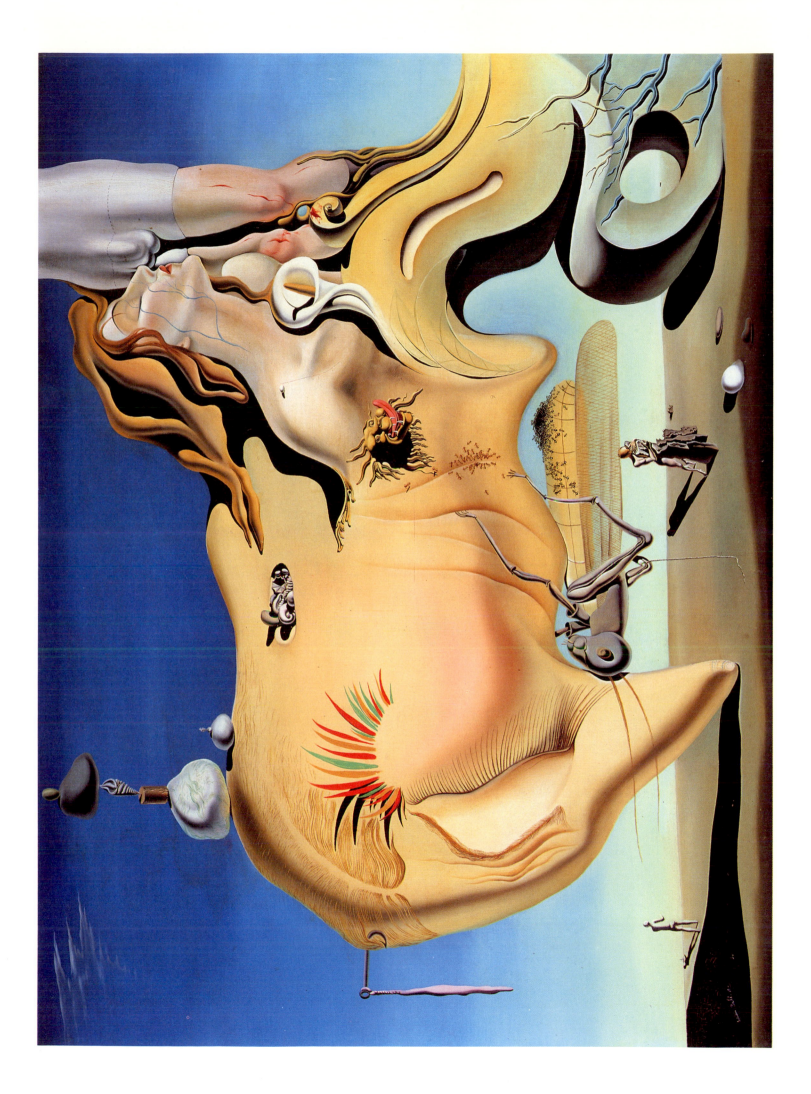

16 The Invisible Man

1929–33. Oil on canvas, 140 x 81 cm. Museo Nacional Centro de Arte Reina Sofia, Madrid.

In *The Secret Life of Salvador Dalí* the artist describes 'the invisible man' as a 'personage with benevolent smile...which still serves to exorcise all my terrors'. However, even he was prepared to admit that as a double image the painting was not entirely successful, although it does allow the viewer to interpret it as representing either a mysterious ruined landscape or a full-length male figure. Dalí's original inspiration for this work came from an illustration of Egyptian ruins that he remembered from a children's book. Dalí's version of the landscape is marred by its artificiality, in that its various features have too obviously been determined by the need to build up the image of the man. This is particularly obvious in the shape of the cloud that doubles as the man's hair and in the elongated, inclined neck of the statue that forms his right arm. The result of this is that the images of both the landscape and the male figure are rather unconvincing.

The difficulty that Dalí had with this painting was reflected in the fact that he worked on it from 1929 to 1933, and even then did not finish it. Nonetheless, in 1931 Dalí regarded the work as sufficiently important to be exhibited incomplete at the Pierre Colle gallery in Paris, where it was inaccurately subtitled '1929–32'. By this time he had already published a book with a corresponding title, *The Visible Woman*. In this work Dalí gave a detailed account of his paranoiac method, in which double images played such a vital role. In the following years he was to develop the technique with far more spectacular results.

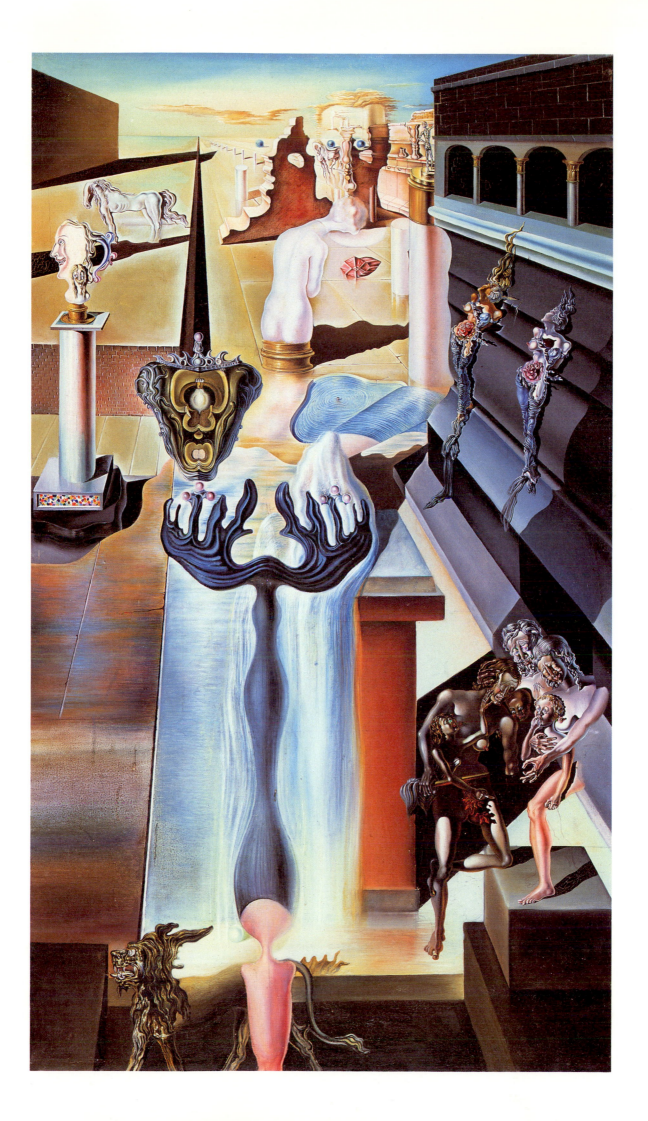

Gradiva Finds the Anthropomorphic Ruins

1931. Oil on canvas, 65 x 54 cm. Fundación Colección Thyssen-Bornemisza, Madrid

Dalí continually mythologized his wife Gala through his paintings. Here he associates her with Gradiva, the heroine of an early twentieth-century novel by Wilhelm Jensen entitled *Gradiva: A Pompeian Fantasy*. It is the story of a young man who falls in love with a plaster cast of a Classical relief and then meets a woman at Pompeii who is remarkably like the sculpted figure. The novel fascinated both Freud and the Surrealists, and Dalí equated Gradiva's redemption of the young man in the book with his own salvation by Gala. Predictably his pictorial references to Jensen's characters are far from straightforward, preventing any neat symbolic interpretation. In *William Tell* (Fig. 10) of 1930 the relief that so fascinated the hero of Jensen's book appears in a detail, but it is combined with Dalí's own extraordinary depiction of another story, that of William Tell. Both *William Tell* and the slightly later *Gradiva Finds the Anthropomorphic Ruins* are characterized by a dominant greenish tone, which adds to their lugubrious, disquieting qualities.

While the allusion to the Gradiva story in *William Tell* is somewhat obscure, this painting is even more enigmatic. It is dominated by a large monolithic figure, exemplifying Dalí's fascination with the anthropomorphic qualities of rocks and ruined structures, as already demonstrated in both *The Great Masturbator* (Plate 15) and *The Invisible Man* (Plate 16). The menhir-like man in this canvas has only limited human characteristics, with a gaping hole instead of a face, recalling certain works of De Chirico. Both De Chirico and Dalí were heavily influenced by the melancholy paintings of the Swiss artist Arnold Böcklin (1827–1901), whose favourite motif, the cypress tree, reappears in the background of this work. The general atmosphere of gloom is completed by the monolith's embrace of a shrouded Gradiva, an image that is characteristic of Dalí's morbid attitude to physical love, despite his claim that 'Gala drove the forces of death out of me.' As this work demonstrates, these forces continued to preoccupy him in his art.

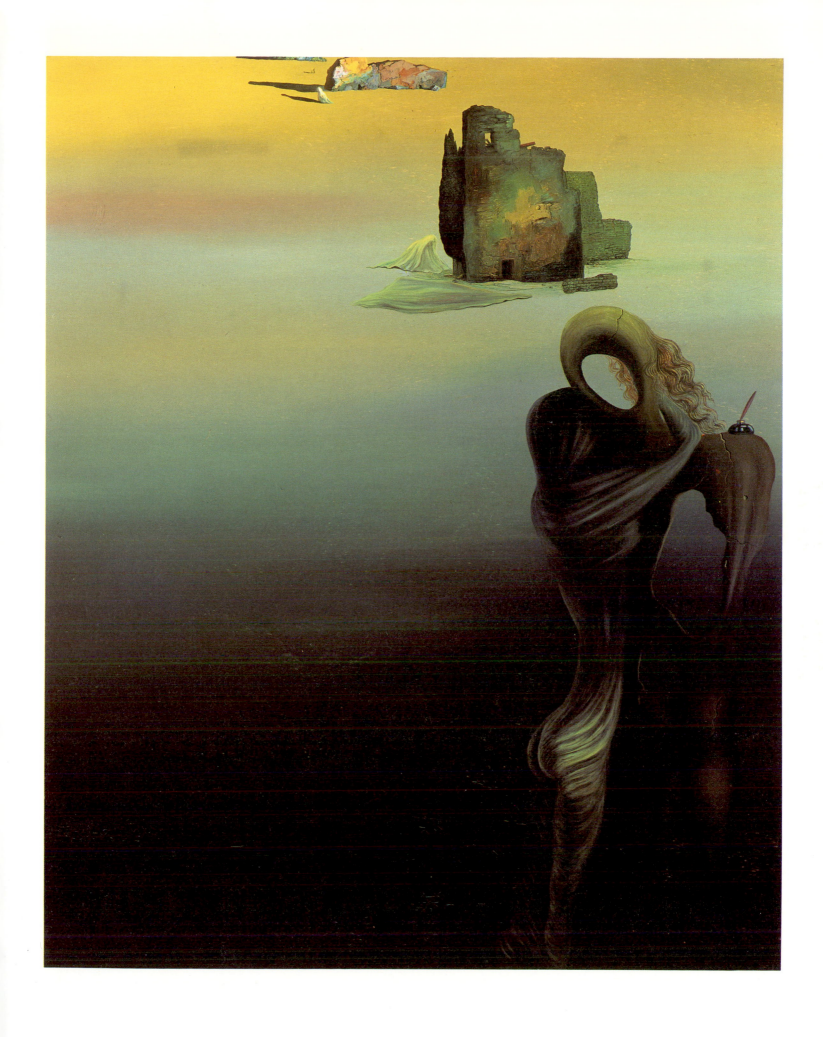

18

Partial Hallucination: Six Apparitions of Lenin on a Piano

1931. Oil on canvas, 114 x 146 cm. Musée National d'Art Moderne, Centre Georges Pompidou, Paris

Fig. 25
The Nostalgia of the Cannibal
1932. Oil on canvas,
47.2 x 47.2 cm.
Sprengel Museum,
Hanover

Lenin's place in the pantheon of Surrealist heroes was well established by the time Dalí joined the movement. However, in the eyes of Dalí, for whom 'Marxism...was no more important than a fart, except that a fart relieves me and inspires me', Lenin was merely one of the many characters of his paranoiac-critical fantasies. Lenin appears on several occasions in paintings that also feature Dalí's other favourite subjects, including *Gala and* The Angelus *of Millet before the Imminent Arrival of the Conical Anamorphoses* (Plate 21). While the work illustrated here makes no direct allusion to Millet's painting, it was related to an experience that Dalí describes in his book *The Tragic Myth of Millet's Angelus*: 'In 1932, at bedtime, I see the bluish and very shiny keyboard of a piano whose perspective offers me a decreasing series of little yellow phosphorescent haloes surrounding Lenin's face.' Dalí takes pains to stress that this vision took place while he was still wide awake, distinguishing it from so-called hypnagogic images which came to him while he was asleep. This painting also refers to an occasion when Dalí was punished as a child by being locked in a room in which he discovered a dish of cherries; these reappear in the bottom left-hand corner of the canvas.

Dalí's practice of bringing together allusions to vivid but seemingly unrelated experiences is echoed in his book *The Tragic Myth of Millet's Angelus*. In this he follows the account of his vision of Lenin's face with a description of the imaginary ink-wells and fried eggs that appeared to him later in the summer, inspiring *The Nostalgia of the Cannibal* (Fig. 25). The paintings inspired by these separate experiences have certain formal qualities in common: both contain a horizontal row of objects in a rhythmic pattern, with the same colours of yellow, white and black. Their most important connection, however, is discussed in *The Tragic Myth of Millet's Angelus*, where they are linked with the repeated representation of *The Angelus* that Dalí saw in a tea-service in a shop. This exemplifies the length to which Dalí's paranoia-criticism would go in the association and interpretation of 'delirious phenomena'.

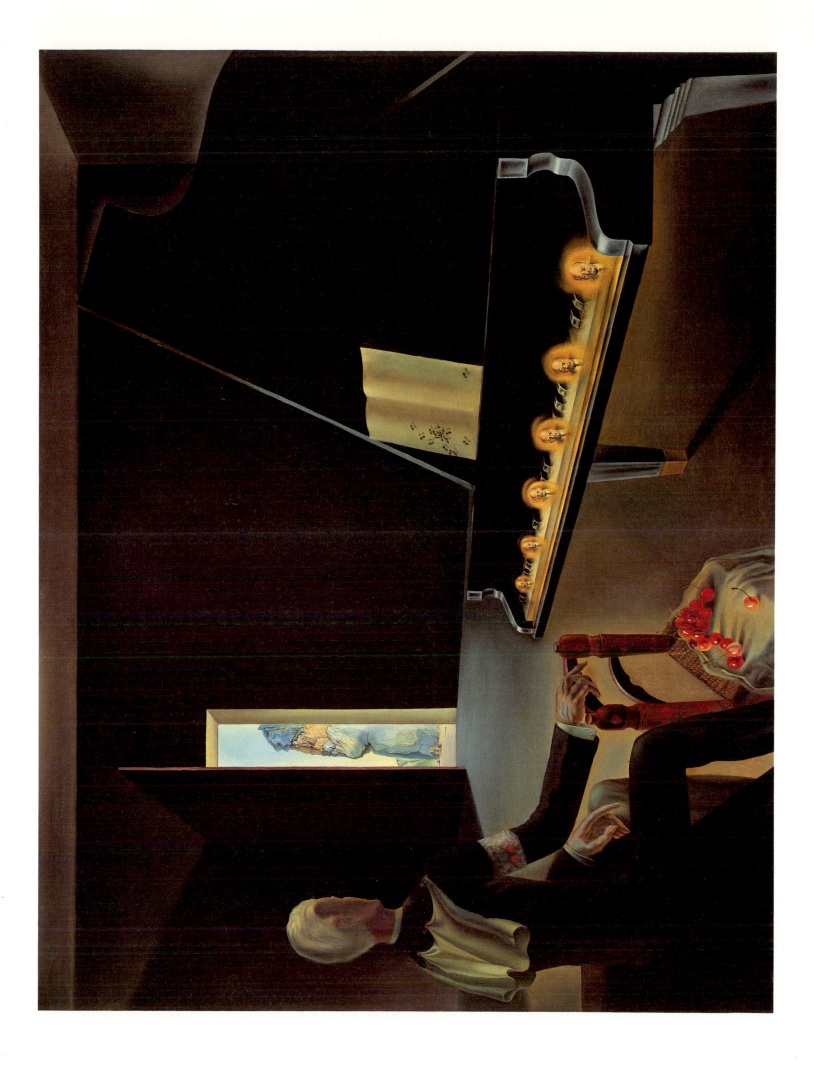

The Persistence of Memory

1931. Oil on canvas, 24.1 x 33 cm. Museum of Modern Art, New York

Dalí describes the evolution of this famous image in his autobiography *The Secret Life of Salvador Dalí*. The extraordinary soft watches were inspired by the remains of a camembert which Dalí contemplated one evening after dinner, when he stayed at home with a migraine while Gala went to the cinema with some friends. Having meditated on the 'super-softness' of the cheese, Dalí went to his studio, where he suddenly realized how he should finish the bare twilight view of Port Lligat that he had begun earlier. Within two hours he had added the watches, and so created his most celebrated painting.

Throughout his career Dalí explored his fascination with softness in many works. However, none have a more obvious sexual significance than the limp watches in this painting, hanging from the branch of the olive tree or draped over the drooping face of Dalí. This is not to say that *The Persistence of Memory* is just about the physical functions of Dalí's body. He also equated the qualities of softness and hardness with aspects of his psychological condition. In his account of the creation of the work Dalí described his inner state as characterized by 'super-softness', in contrast to his public image, which was, thanks to Gala's influence, as hard as a 'hermit-crab's shell'. Dalí's highly personal interpretation of the painting even extended to claiming that it represented 'the horrible traumatism of birth by which we are expunged from paradise'. Certainly the watches, all stopped at different times, create a sensation of timelessness which is associated with life in·the womb.

In the post-war period Dalí also linked *The Persistence of Memory* to his increasing interest in modern science, in which the old absolute notions of space and time had been destroyed by the theory of relativity. For Dalí this scientific disruption of the common-sense view of the universe accorded with his own assault on reality through paranoia-criticism, which relied on his memories of moments of extreme irrational intuition. His view was summed up perfectly in *The Unspeakable Confessions of Salvador Dalí*: 'Somebody someday will have to wind up my limp watches so they can tell the time of absolute memory, the only true and prophetic time.'

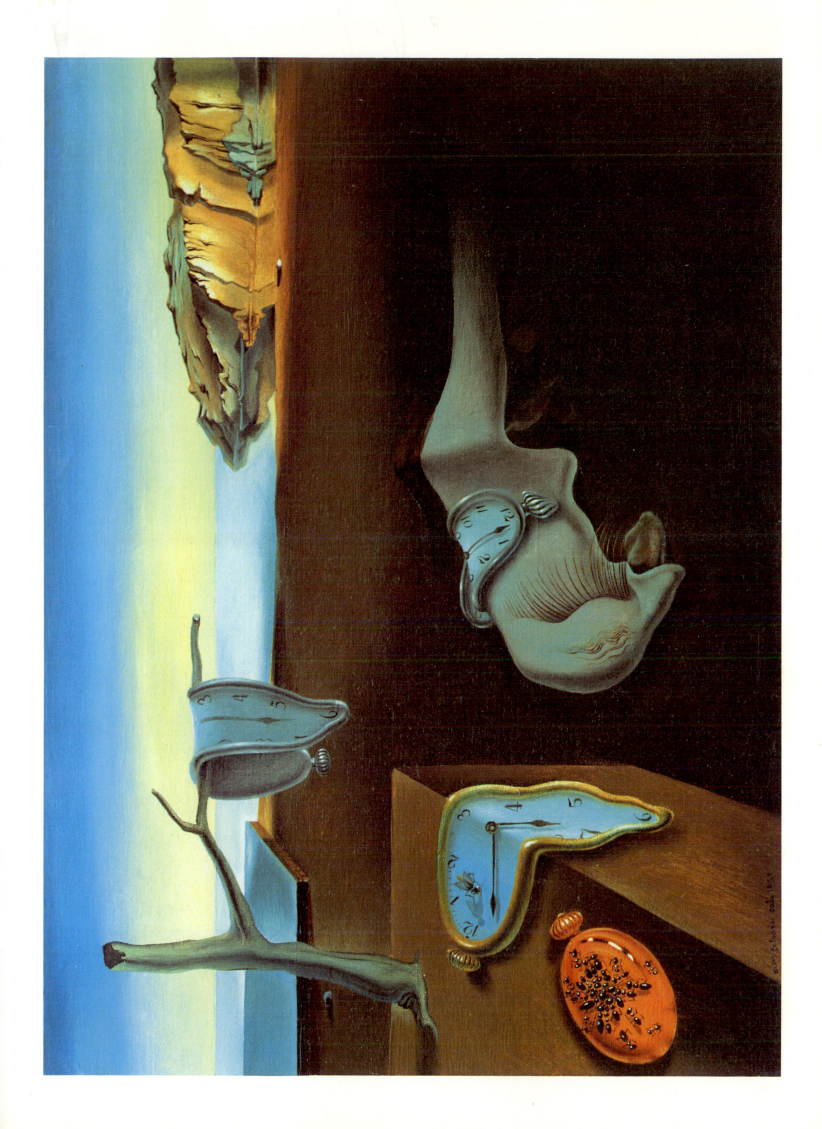

The Enigma of William Tell

1933. Oil on canvas, 201.5 x 346 cm. Moderna Museet, Stockholm

Dalí's depiction of Lenin in this work seriously offended the other Surrealists when it was shown in 1934 at the Salon des Indépendants in Paris. Given their Marxist convictions, it is not difficult to see why a group of Surrealists even tried to damage it at the exhibition: fortunately, according to Dalí, they were unable to reach it. The painting represents Lenin stripped from the waist downwards with an enormous bare buttock, which Dalí described as 'shaped like a breakfast roll with its end held up by a forked crutch'. The irreverence of this image is aggravated by Dalí's additional statement that the 'buttock, of course, was the symbol of the Revolution of October 1917.' The motif of the soft watch, first developed in *The Persistence of Memory* (Plate 19), reappears on a marble plinth; its limpness is visibly reflected in the enormous peak of Dalí's cap, which, like Lenin's buttock, also requires artificial support. Why Lenin should have been selected for such unenviable treatment is not entirely clear, nor is it meant to be. However, the meaning of the painting is suggested by the title inscribed on the plinth: Lenin is identified with William Tell, who, according to Dalí, represented the oppressive father-figure against whom Dalí was himself rebelling at that time.

The threat that the William Tell character is posing in this painting was vividly described by Dalí much later in an article in the periodical *Twentieth Century* entitled 'The Enigma of Salvador Dalí'. There he describes how Tell is holding a baby, who has a raw cutlet on his head rather than the apple that is associated with the Tell legend. According to Dalí, the meat is a clear sign that the father intends to eat his son. His savagery is demonstrated a little more subtly by the presence of a tiny nutshell and a miniature cradle and baby, which look as if they might be crushed at any moment by Tell's enormous sandalled foot. With extreme precision Dalí explains this image as representing his beloved Gala, whose relationship with Dalí had been one of the original causes of his rupture with his father. While it may come as a relief to be given such a clear interpretation of one of Dalí's paintings, *The Enigma of William Tell* arguably lacks the poetic ambiguity and subtlety that characterizes so many of Dalí's other works of this period.

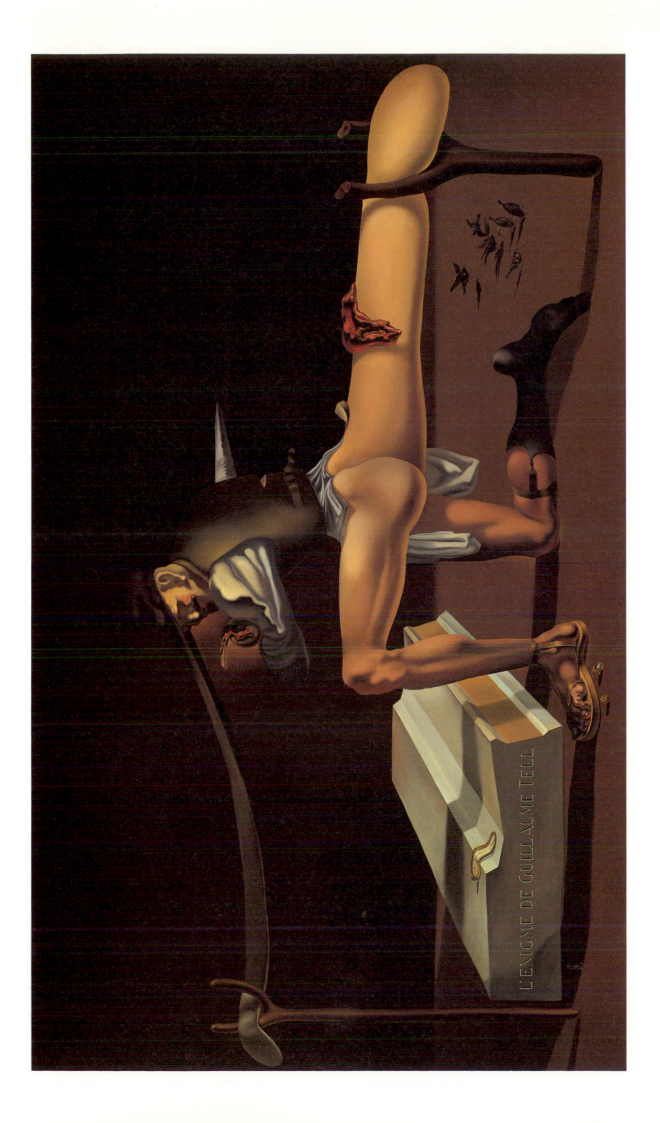

Gala and *The Angelus* of Millet before the Imminent Arrival of the Conical Anamorphoses

1933. Oil on panel, 24 x 18.8 cm. National Gallery of Canada, Ottawa

In this work Lenin, recognizable from his bald head and moustache, escapes the full force of Dalí's distorted fantasy. This is directed instead at the Russian writer and revolutionary Maxim Gorky, the lobster-headed figure on the left. Both characters are involved in a bizarre encounter with Gala, for which the reproduction of Millet's *The Angelus* (Fig. 26) above the door perhaps offers a partial explanation. In his writings Dalí characterized both Gala and the woman in Millet's painting as embodying female dominance, although he certainly regarded Gala far more positively than he did the figure in *The Angelus*. Dalí saw *The Angelus* as the maternal variant of the myth of William Tell, which he had already interpreted in accordance with his own neurotic fears concerning his father. While Dalí cast Lenin as Tell in *The Enigma of William Tell* (Plate 20), in this work the role of the Russian leader is secondary to that of Gala. Indeed Gala, grotesquely grinning at the far end of the room, could be seen as posing a threat to her companion in this painting, just as the male figure in *The Angelus* is supposedly menaced by the woman. Whatever the force of these analogies, the device of a painting within a painting enriches the work's exploration of familiar psychological obsessions, even if it cannot, nor is intended, to offer a clear explanation.

Fig. 26
JEAN-FRANÇOIS MILLET
The Angelus
1858–9. Oil on canvas,
55 x 66 cm.
Musée d'Orsay, Paris

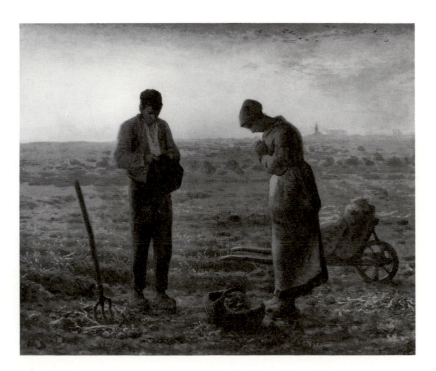

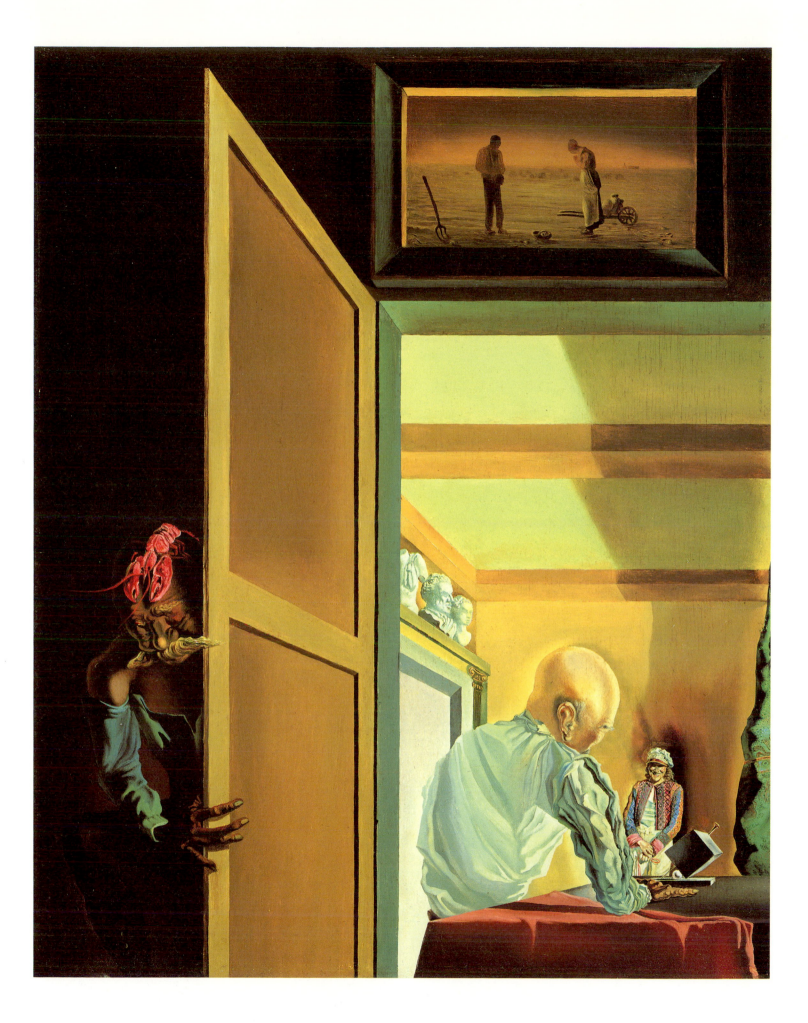

Phantom Waggon

1933. Oil on canvas, 16 x 20.3 cm. Yale University Art Gallery, New Haven, CT

The technique of the double image was rarely executed with as much simplicity as in *Phantom Waggon*. The two figures in the cart, which is travelling across the plain of Ampurdan, also represent the towers in the town that the waggon is approaching, while the wheels double as stakes stuck in the sand. Apart from this relatively straightforward piece of paranoia-criticism, the painting is remarkably empty. In this respect it resembles a slightly later series of beach scenes, such as *Paranoiac-astral Image* (Fig. 27), which is also dominated by sand and sky. Like *Phantom Waggon*, most of these works include an image of a broken amphora, a reference to the vestiges of Classical civilization in Dalí's native Catalonia, which adds to the paintings' vivid sense of desertion.

Fig. 27
Paranoiac-astral Image
1935. Oil on wood,
16 x 21.8 cm.
Wadsworth Atheneum,
Hartford, CT

The Spectre of Sex Appeal

1934. Oil on canvas, 18 x 14 cm. Fundacio Gala-Salvador Dalí, Figueras

The boy in a sailor-suit in the bottom right is plainly meant to represent the young Dalí. Indeed his elegant costume is identical to Dalí's own description of his school outfit, so gorgeous and expensive in comparison with the clothes of his fellow pupils. Dalí has located the child in front of a rocky promontory on the Costa Brava. He is shown gazing up at a headless female giant, with a cushion-shaped rock tied to her stomach and two sacks for breasts. This figure also appears in Dalí's illustrations for the Comte de Lautréamont's book *The Songs of Maldoror*, which were done at the same time.

Dalí has produced a memorable emblem of his own sexual fears, rooted in the experiences of his claustrophobic, spoiled childhood. Instead of creating a double image subject to alternative mutually exclusive readings, he has produced a terrifying composite creature, whose principal physical quality – 'decomposition, destruction of illusory volume' – accords perfectly with his own definition of a 'spectre', published in the Surrealist magazine *Minotaure* in 1934. The sight of this monster appears at first sight to have had a strange effect on the boy's penis, but a closer glance reveals that he is merely holding a bone, together with his hoop. Nonetheless. the illusion of an ossified phallus completes this powerful image of sexual inhibition.

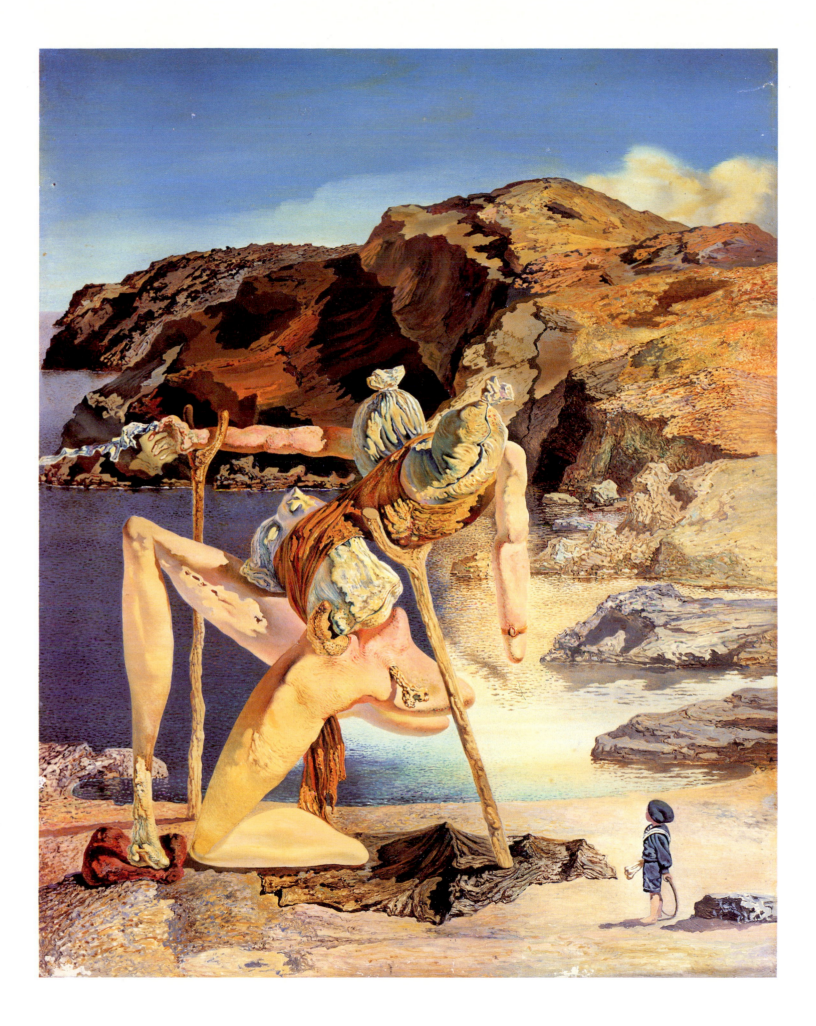

Portrait of Gala

1935. Oil on canvas, 32.4 x 26.7 cm. Museum of Modern Art, New York

Dalí's early portraits of his sister Ana Maria represent her from different angles, but this painting is unusual in combining different views of Gala on the same canvas. As well as manipulating reality in this way, Dalí has also deliberately altered the composition of *The Angelus* hanging on the wall behind Gala. The wheelbarrow located behind the woman in Millet's original becomes much more prominent in Dalí's painting: both the characters in Dalí's version of *The Angelus* are seated on it, as is one of the images of Gala. For Dalí the wheelbarrow had an intense sexual significance, since he believed that peasants responded to their laborious lives by 'eroticizing' their tools. Certainly it is not difficult to see how Dalí was able to argue for a phallic interpretation of the pitchfork thrust into the ground in Millet's painting. However, for his explanation of the wheelbarrow Dalí was obliged to plunder other sources, particularly postcards and folk pictures, which he claimed demonstrated the way in which that seemingly mundane instrument could represent both the peasants' sexuality and the threat of mutilation posed by the women to their men. The association of Gala with these disturbing themes may seem strange considering Dalí's perception of her as his saviour. However, in Dalí's words, her great gift was that through her inspiration: 'I achieved the sublime mutation of evil into good, madness into order, and even succeeded in getting my contemporaries to accept and share my madness.'

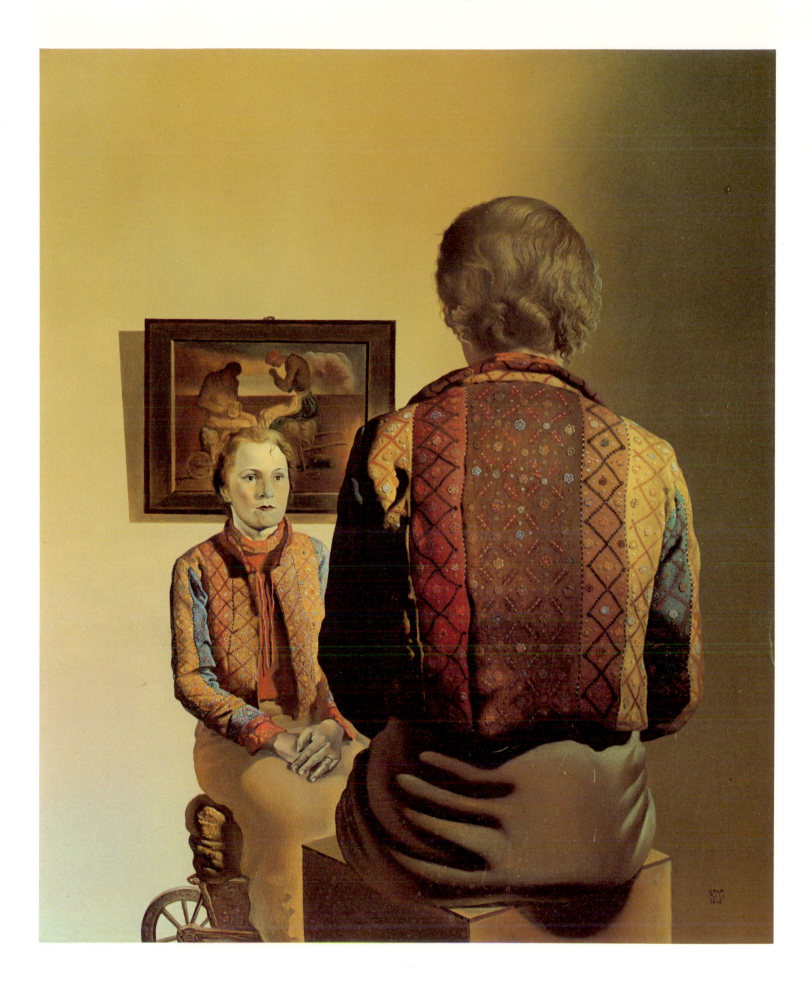

Mae West's Lips Sofa

1936–7. Wooden frame covered with pink satin, h86 cm. Private collection, on loan to
the Victoria and Albert Museum, London

Fig. 28
The Face of Mae
West
1934–5. Gouache on news-
paper, 31 x 17 cm.
Art Institute, Chicago, IL

Dalí's fascination with the American actress Mae West was long-lived. A
gouache now in Chicago (see Fig. 28) illustrates his original plan for a
paranoiac-critical room based on the features of her face. Unfortunately
the project remained unexecuted until the opening of the Dalí Museum
in Figueras in 1974. However, during the 1930s Dalí did manage to have
several sofas made according to his design. The one illustrated here was
commissioned by the important British patron Edward James, whom Dalí
described as the 'humming-bird poet' who 'bought the best Dalís, and
was naturally the richest'. The sofa is the same colour as the 'Shocking
pink' lipstick developed by the fashion designer Elsa Schiaparelli, for
whom Dalí himself designed hats and dresses in 1937. The sofa's shape
derives not only from Mae West's lips, but also from other sources, includ-
ing the luxurious curves of Gaudi's architecture. With typical perversity,
Dalí took his principal inspiration from a particularly irregular and uncom-
fortable rocky formation near Cadaqués. As he himself said, Surrealist
objects were never meant to be practical.

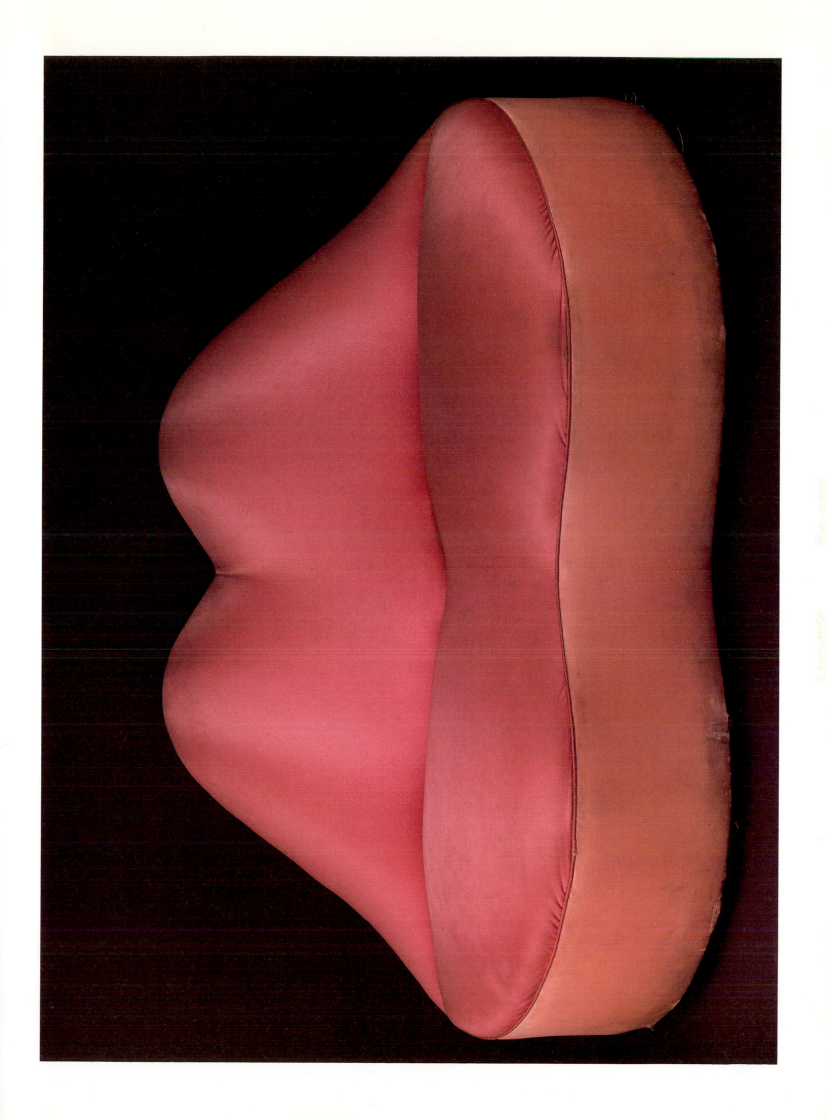

Lobster Telephone

1936. Steel, plaster, rubber, resin and paper, h30 cm. Tate Gallery, London

Edward James also commissioned this work, in which a piece of modern technology, rendered useless but fascinating by Dalí's intervention, is combined with another of Dalí's familiar fetishes – the lobster, which frequently appeared in his works of the period (see Plate 21 and Fig. 29). In *The Unspeakable Confessions of Salvador Dalí* he describes how the fishermen of Cadaqués hung live lobsters from the altarpieces of the local churches 'so the death throes of the crustaceans might help them better to follow the Passion of the Mass'. Evidently his appreciation of the lobster's uses did not stop there, since in the *Abridged Dictionary of Surrealism* of 1938 he provided a memorable definition of 'aphrodisiac telephones', in which the 'receivers are replaced by lobsters, whose advanced state is proved by phosphorescent plates, true truffled fly-catchers'. While this was an example of lobsters being substituted for telephones, the process could also happen in reverse. As he confessed in *The Secret Life of Salvador Dalí*: 'I do not understand why, when I ask for a grilled lobster in a restaurant, I am never served a cooked telephone.' As so often with Dalí, the edibility of these objects had definite sexual associations. This was particularly true of the lobster, whose hard shell forms such a satisfying contrast to the soft flesh beneath it. It is perhaps no accident that in *Lobster Telephone* the animal's tail, which contains its sexual parts, is positioned over the mouthpiece of the telephone. Having established the erotic significance of the lobster in this relatively subtle way, it was only a small step to the more audacious use of the animal in Dalí's ill-fated American extravaganza the *Dream of Venus* (see Fig. 30).

Fig. 29
Minotaure
1936. Cover of the journal
Minotaure, No. 8

Fig. 30
GEORGE PLATT LYNES
Dalí, a Model and a
Lobster
1939. Photograph made for
the *Dream of Venus* for the
International World Fair in
New York

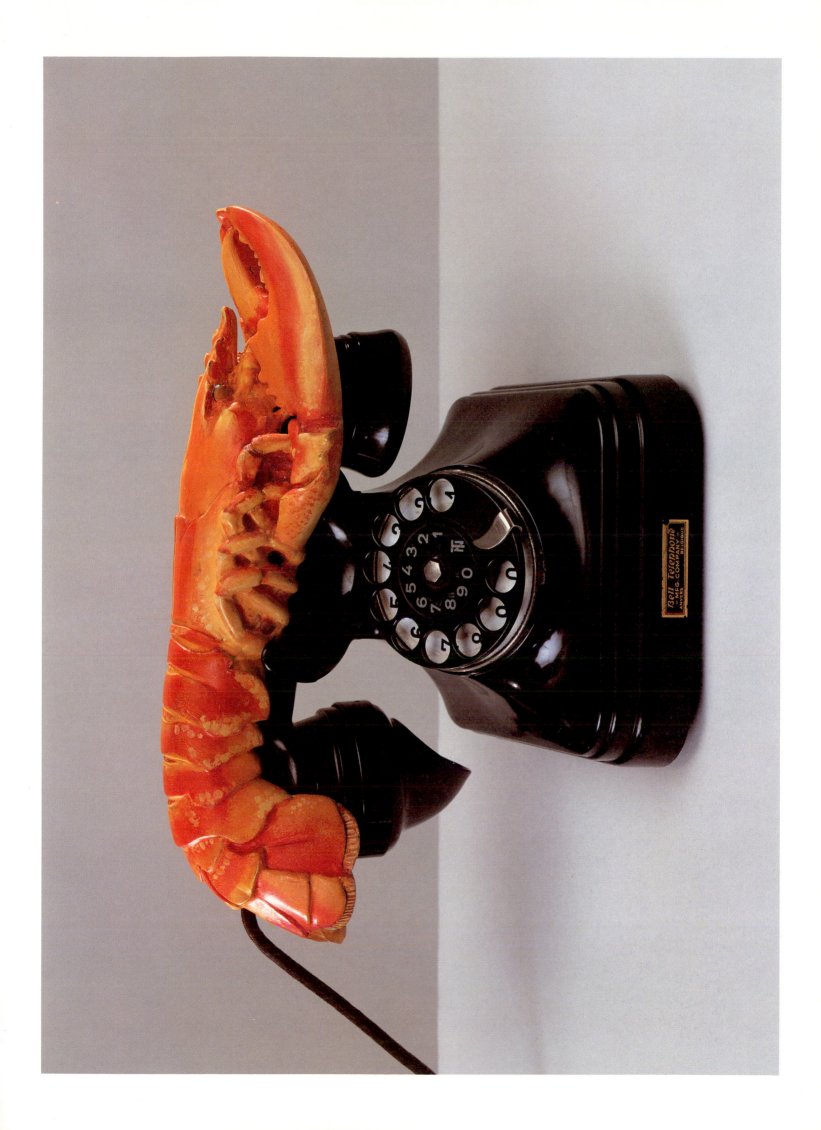

27 Suburbs of the Paranoiac-critical City:
 Afternoon on the Fringes of European History

1936. Oil on wood, 46 x 66 cm. Private collection

In this disquieting painting Dalí has created a sequence of eerie town-scapes, which forms the background to the remarkable figure of Gala holding up a bunch of grapes. In a sense this work does not contain double images, since the identities of the individual objects in the painting are unambiguous, even if their real significance is enigmatic. However, the painting does appear to have been largely determined by another kind of formal ambiguity: the recurrence of certain shapes that represent a different subject at each appearance. The way in which Dalí developed this technique is brilliantly demonstrated by a surviving page of preparatory sketches (Private collection), in which the same form appears in the images of the grapes, the skull and the backside of the horse. It is possible that Dalí first decided to depict the grapes, which he vividly recalled Gala eating during their first summer together: 'I had only to close my eyes to recapture intact the picture of Gala gleaning the grapes.' This image would then have generated the other forms in the sketch.

The formal connections between the various elements of the painting in fact go far beyond those outlined in the drawing, creating a visual order that belies the actual irrationality of the work's iconography. The three settings all refer to actual locations in Catalonia, but their juxtaposition, apparently influenced by the early work of De Chirico, adds to the painting's sense of surreality and disorientation. Even the references to the classical tradition, the Raphaelesque building on the left and the amphora in the foreground, give a rather disjointed sense of historical continuity: it is no coincidence that the subtitle of the painting refers to the outskirts of European history. Nonetheless, this work undoubtedly looks forward to the distinctive brand of classicism that was increasingly to dominate Dalí's art.

Soft Construction with Boiled Beans: Premonition of Civil War

1936. Oil on canvas, 110 x 84 cm. Museum of Art, Philadelphia, PA

This enormous figure, towering over the landscape, was obviously inspired by the Spanish artist Francisco Goya (1746–1828) whose painting of *The Colossus* (Museo Nacional del Prado, Madrid) depicts a giant rising above a scene of chaos during the Napoleonic invasion of Spain. Dalí's creation is even more grotesque than Goya's. As he described it: 'I showed a vast human body breaking out into monstrous excrescences of arms and legs tearing at one another in a delirium of auto-strangulation.' Even though Dalí chose 'auto-strangulation' as a metaphor for the imminent Spanish Civil War, he also once again emphasized the softness, even edibility of his imagery: 'The soft structure of that great mass of flesh in civil war I embellished with a few boiled beans, for one could not imagine swallowing all that unconscious meat without the presence (however uninspiring) of some mealy and melancholy vegetable.' Once again Dalí has fulfilled his conviction that 'the soft, the digestible, the edible, the intestinal are naturally all part of my paranoiac-critical representation of the world.' It is worth adding that in this painting the qualities of softness and elasticity also emphasize the slow, tortuous quality of the creature's self-destruction.

Dalí's own horror at Spain's civil strife was rooted in his own brief experience of revolution in 1934, when Luis Companys proclaimed the Republic of Catalonia. Dalí was in Barcelona at the time and, never a man of great physical courage, promptly fled across the French border. It was this experience that led to the sketches which formed the basis of the painting two years later. Dalí viewed the calamity afflicting Spanish society in the context of the country's enduring aspects, especially its landscape, whose permanence would be confirmed when the War was finally over. The particular terrain depicted in this work is identified by the appearance of the small male figure standing behind the monster's hand. He also appears in Dalí's contemporary painting of *The Ampurdan Chemist Seeking Absolutely Nothing* (Private collection), confirming that the horrific symbol of a nation tearing itself apart is set in the timeless landscape of Dalí's native Ampurdan plain.

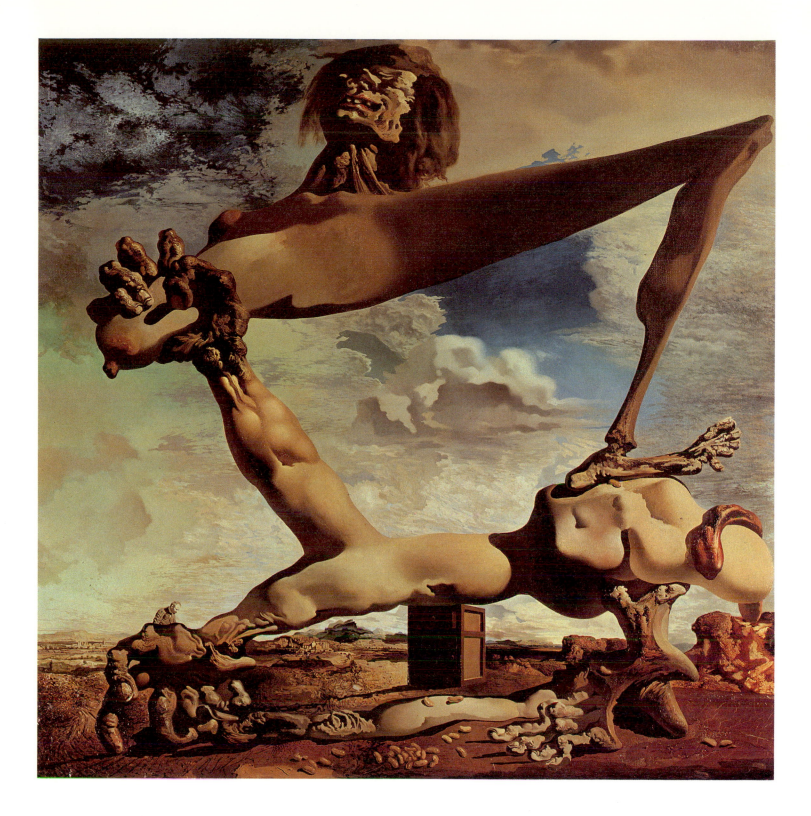

Autumn Cannibalism

1936. Oil on canvas, 65 x 65.2 cm. Tate Gallery, London

In this work Dalí's preoccupation with softness and edibility is even more evident than in *Soft Construction with Boiled Beans: Premonition of Civil War* (Plate 28). Here the Spanish Civil War is represented as a couple consuming each other while locked in a passionate embrace. Unlike the previous painting, where the monster does not appear to be enjoying itself, *Autumn Cannibalism* depicts an almost pleasurable activity. Indeed the horror of the spectacle is intensified by the extreme gentility with which the character on the right holds the spoon, scooping up a piece of his mate's flesh.

By representing the Civil War as a gastronomic experience, however horrific, Dalí expressed his belief that the conflict was a biological rather than political phenomenon. Predictably he gave the work an obviously Catalan setting, even though he recorded that he painted it at the time of the siege of Madrid. The hard, immutable rocks are deliberately contrasted with the soft figures of the cannibals, emphasizing the latters' impermanence. In Dalí's view, their struggle was relatively unimportant, just one of the many natural events that form a landscape. Dalí's ability to make this analogy allowed him to distance himself emotionally from the conflict for the rest of its course, only returning after it had finished 'to recall the existence of sacred values'. In fact the steeple of the church at Cadaqués had been damaged, 30 of his friends had been shot, but, as he later recounted: 'the rocks of Cape Creus still went through their eternal metamorphoses in the iridescent spume of waves shattering on their backs.'

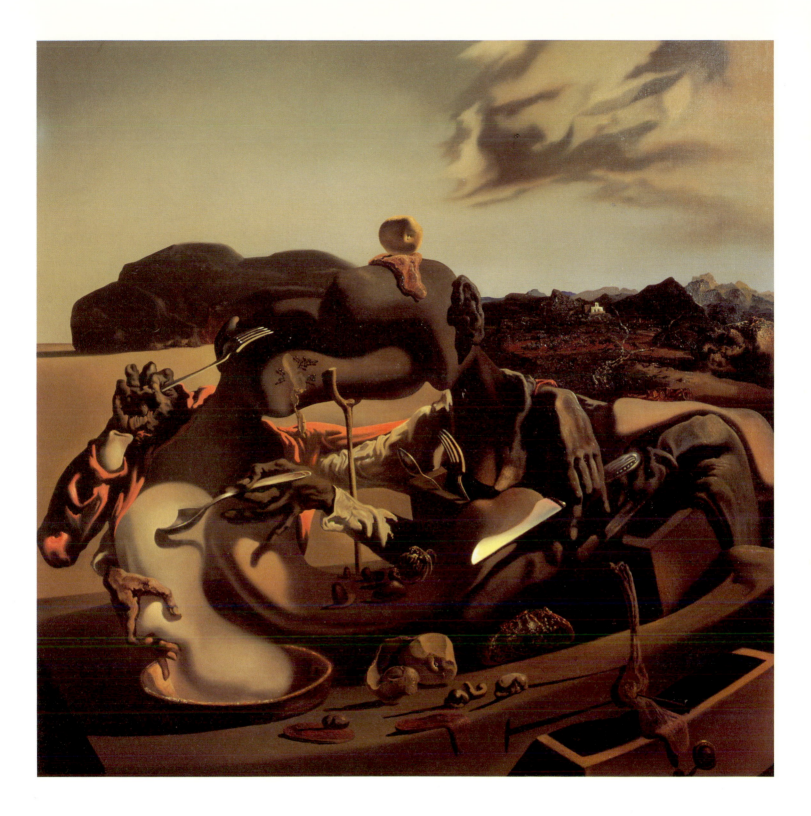

The Metamorphosis of Narcissus

1937. Oil on canvas, 50.8 x 78.2 cm. Tate Gallery, London

Dalí claimed that this painting and the accompanying poem published in 1937 were 'the first poem and the first picture obtained entirely through the integral application of the paranoiac-critical method'. According to Dalí, he was inspired by a conversation that he overheard between two fishermen at Port Lligat: one of the men commented on a boy who spent all day looking at himself in the mirror, to which the other replied that the young man in question had a 'bulb in the head', a common Catalan expression for a mental complex. This exchange made Dalí think of the Classical myth of Narcissus, the youth who fell in love with his reflection in a pool, drowned and was then turned into a flower; after all if a man had a bulb in his head, it might blossom at any moment.

Dalí's visualization of this theme produced one of his most arresting paintings. The form of Narcissus gazing into the pond on the left, as if caught in the process of metamorphosis, is fully transformed on the right of the composition, fitting the description in Dalí's poem: 'Narcissus, in his immobility, absorbed by his reflection with the digestive slowness of carnivorous plants, becomes invisible. All that remains of him is the hallucinatory oval of whiteness of his head...his head held up at the tips of the fingers of water, at the tips of the fingers of the senseless hand.' In the painting the oval white head is converted into a cracked egg, from which springs the flower, 'the new Narcissus', as it is described in the poem.

The image of a hand holding an egg is repeated among the mountains in the background, where it is meant also to represent the god of snow, melting with desire at the onset of spring. The prevailing mood of sexual arousal is completed by the minutely detailed figures in the middle of the painting, whom Dalí helpfully described as the 'heterosexual group'.

As well as being visually exciting, the painting had a profound, if enigmatic, personal significance for Dalí. As he himself said in *The Unspeakable Confessions of Salvador Dalí*, before meeting Gala he had been at 'the point of almost absolute narcissism, particularly during masturbation'. Gala's arrival not only changed his appreciation of sex, but also released him from his obsession with his dead brother Salvador, 'the Castor whose Pollux I had been, and whose shadow I was becoming'. As Dalí described it, Gala became his 'double' or alter ego in place of his dead brother, transforming his morbid narcissism into a positive, creative quality. Above all, Gala enabled Dalí to conquer his various psychological problems and anxieties by expressing them in his art. It is hardly surprising that at the end of the poem he describes the flower bursting from the split head as 'Gala – my narcissus'.

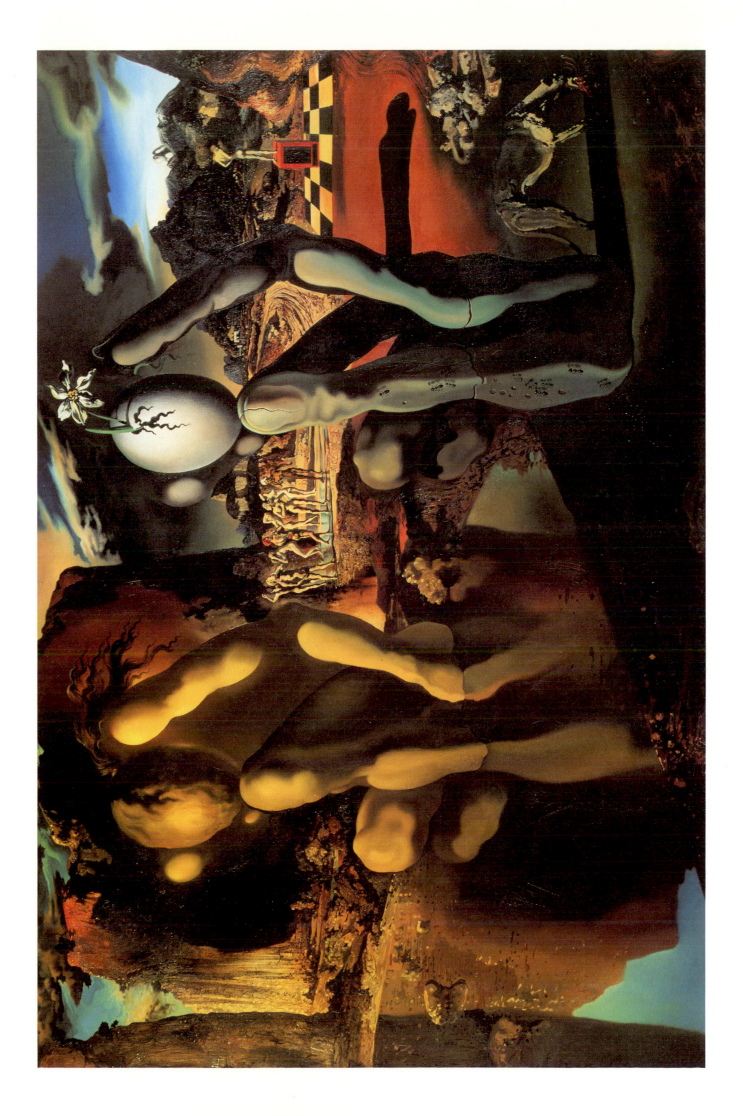

Sleep

1937. Oil on canvas, 51 x 78 cm. Private collection

'I have often imagined and represented the monster of sleep as a heavy, giant head with a tapering body held up by the crutches of reality. When the crutches break, we have the sensation of "falling".' Dalí's account in *The Secret Life of Salvador Dalí* then goes on to suggest that this experience is in fact a memory of the feeling of being born. He also credited some of the most vivid of his paranoiac-critical experiences, such as those recorded in *The Nostalgia of the Cannibal* (Fig. 25), to the onset of sleep. Indeed many of his own Surrealist self-portraits represent himself seemingly asleep, surrounded by dream-like imagery. The figure in this work is situated in a space notable for its emptiness, a quality that Dalí associated with 'extreme anguish'. Nonetheless, on the right of the painting Dalí has included what he described as the 'well-known summering town that appears in the boring dream of Piero della Francesca', a reference to *The Dream of Constantine* in Piero's cycle of 'The Legend of the True Cross' in the church of San Francesco, Arezzo.

While *Sleep* is primarily an expression of one of Dalí's well-established obsessions, he later admitted that it was also a response to more immediate circumstances. As the Spanish Civil War swallowed up the lives of so many of his friends, Dalí felt an overwhelming need to suppress his consciousness of this horrific event. *Sleep* remains a vivid image of this terrible necessity.

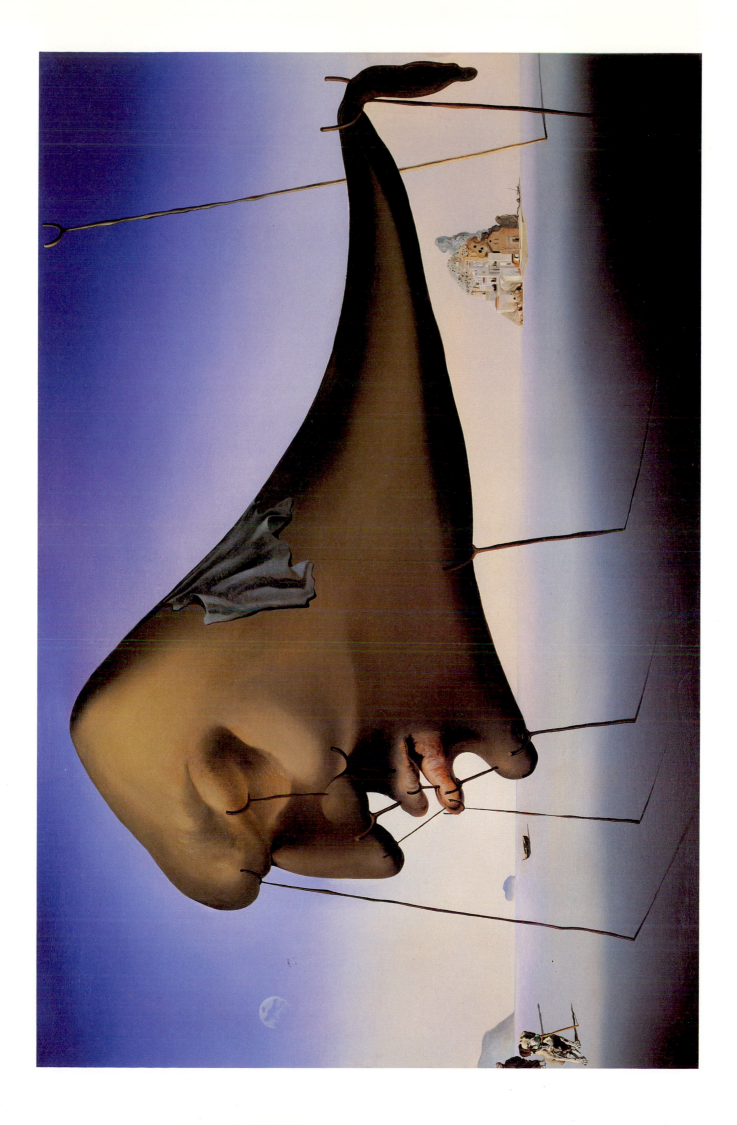

Impressions of Africa

1938. Oil on canvas, 91.5 x 117.5 cm. Museum Boymans-van Beuningen, Rotterdam

This canvas was named after a play by the French writer and chess-player Raymond Roussel, whose work was admiringly described by Dalí in 1933 as being 'on the borderland of mental deficiency'. The painting in fact records Dalí's impressions not of Africa but of Sicily, where Roussel had killed himself in 1933, and was executed in Rome at the home of the British collector Lord Berners. It was not like Dalí, however, to be put off by the prosaic realities of geography: 'Africa', he argued, 'accounts for something in my work, since without ever having been there I remember so much about it.' Although Dalí's knowledge of Africa is reflected in the painting's arid setting, the dramatically foreshortened figure of himself at his easel demonstrates his encounter with Italian Baroque art. Dalí is presented as a seer, whose paranoiac-critical visions populate the background of the painting. Familiar iconography, such as the faces of Gala and a donkey, operate as double images, representing part of an arcaded building and the figure of a priest respectively. Gala's prominent position immediately above Dalí's head suggests that as usual she is his principal source of inspiration. While the painting is undoubtedly consistent with much of Dalí's earlier paranoia-criticism, its reference to Italian art anticipates later developments in his career, which confirmed his opinion that: 'I think I shall succeed in being a classicist while still remaining paranoiac.'

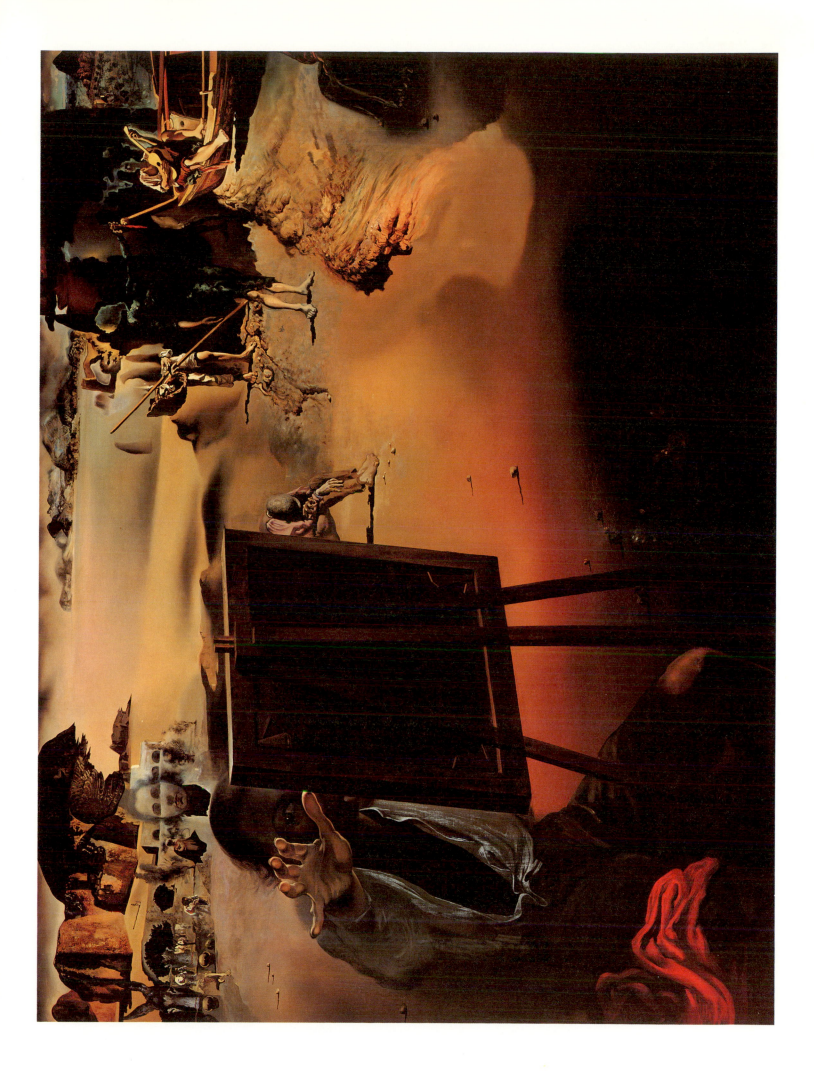

Mountain Lake

1938. Oil on canvas, 73 x 92 cm. Tate Gallery, London

At first sight it is hard to see how this seemingly inoffensive image could be among the works that enraged the Surrealists with their political content. Its actual significance, however, is made clear by a comparison with the slightly earlier painting *The Enigma of Hitler* (Fig. 31). In this work the umbrella, an attribute of the British Prime Minister Neville Chamberlain, and the tiny image of Hitler on the plate indicate that the telephone is alluding to the negotiations surrounding the Munich agreement, the treaty that led Chamberlain to deliver the empty promise of 'peace in our time'. Indeed Dalí himself said that the painting was based on a series of dreams caused by the events of Munich. While the limp receiver hanging from a branch in *The Enigma of Hitler* recalls *The Persistence of Memory* (Plate 19), *Mountain Lake* uses another of Dalí's fetishes, the crutch, to express the precariousness of the situation. The lack of explicit references to Hitler and Chamberlain not only makes *Mountain Lake* more enigmatic but also adds to the expressive isolation of the telephone. In a final twist the phallus-shaped lake resembles a fish on a table, a motif that Dalí had used years previously in *Still Life by Moonlight* (Plate 8). In this way Dalí creates a particularly sombre still life or, as it is in French, a 'nature morte' or 'dead life'.

Fig. 31
The Enigma of Hitler
1937. Oil on panel,
94 x 141 cm.
Private collection

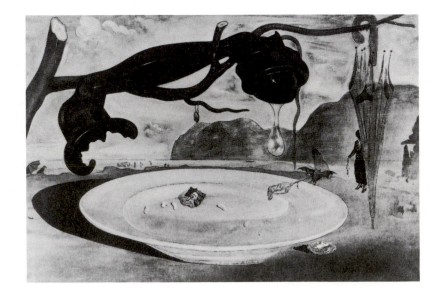

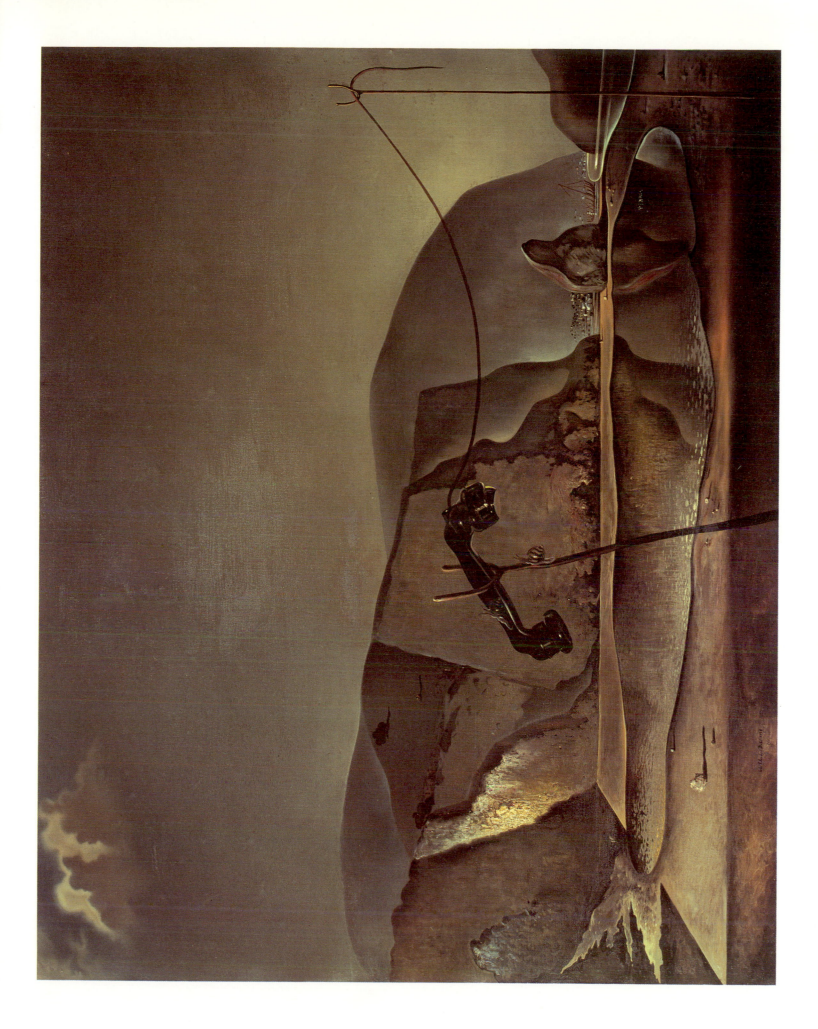

Spain

1938. Oil on canvas, 91.8 x 60.2 cm. Museum Boymans-van Beuningen, Rotterdam

Fig. 32
The Great Paranoiac
1936. Oil on canvas,
62 x 62 cm.
Museum Boymans-van
Beuningen, Rotterdam

This painting is one of a group of paranoiac-critical works in which tiny figures are used to create larger human images; another celebrated example is *The Great Paranoiac* (Fig. 32). *Spain* consists of a woman in classical dress and pose, constructed out of minute, fighting horsemen, who recall the warriors in the background of Leonardo da Vinci's *Adoration of the Magi* (Galleria degli Uffizi, Florence). Both paintings have the same sandy-brown, unfinished quality, which is also present in *The Great Paranoiac*. The only patches of brightness in *Spain*, significantly in a blood-red colour, are the cloth hanging from the drawer and the woman's lips and nipples, made up of a cloak and the heads of two horsemen. While the *Adoration of the Magi* was undeniably an important source for this painting, Leonardo was also influential in a much more profound way: both Dalí and the German Surrealist Ernst were aware of Leonardo's description of the way in which the patterns of mossy walls, clouds and ashes inspired his own pictorial forms. Indeed in 1941, after his relationship with Dalí had completely broken down, Breton claimed that Dalí's paranoiac-critical method had merely copied both Leonardo and Ernst. However, in *The Secret Life of Salvador Dalí* the artist gave a seemingly authentic account of how as a child he gazed at the stains on the walls of his school: 'my eyes would untiringly follow the vague irregularities of these mouldy silhouettes and I saw rising from this chaos...progressively concrete images which by degrees became endowed with an increasingly precise, detailed and realistic personality.' As he himself said, this experience became 'the keystone of my future aesthetic'.

As well as being one of Dalí's more ingenious double images, this work alludes to the contemporary fighting in Spain in a characteristically indirect, even lyrical way. *Spain* offers a remarkable insight into the depth of Dalí's desire to detach himself from the conflict raging in his native land.

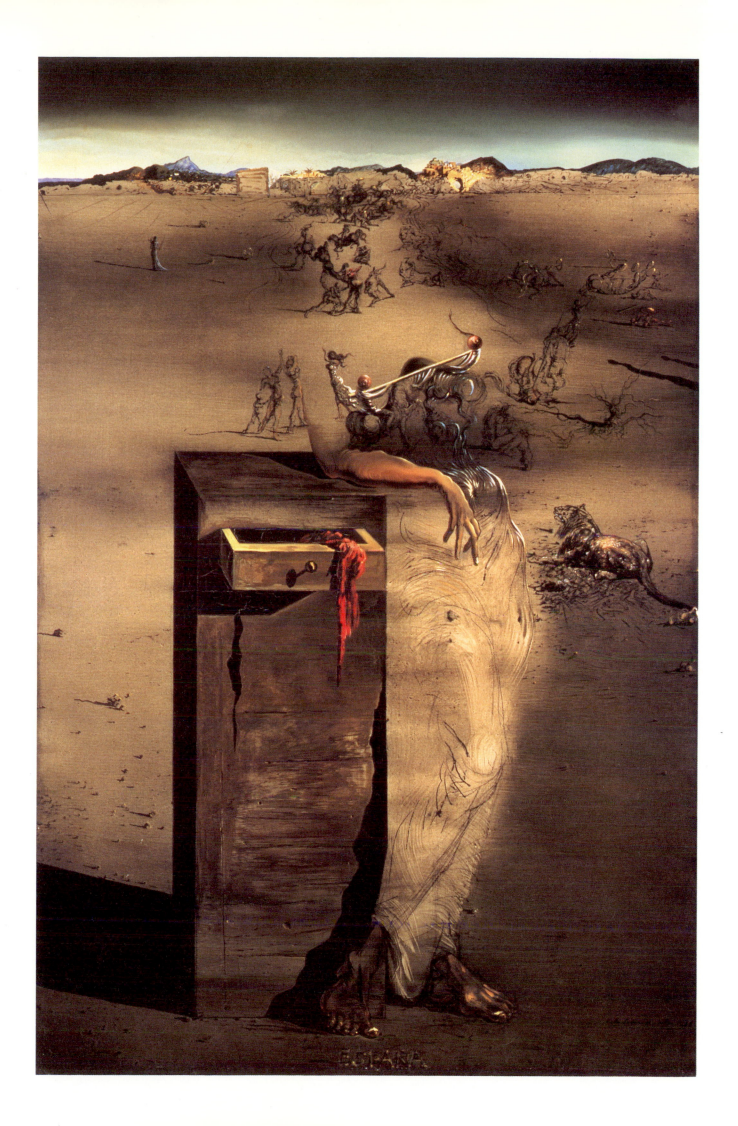

Slave Market with the Disappearing Bust of Voltaire

1940. Oil on canvas, 46.5 x 65.5 cm. Salvador Dalí Museum, St Petersburg, FL

Once again Dalí has used a celebrated work of art, on this occasion a bust by the French sculptor Jean-Antoine Houdon (1741–1828), now in the Metropolitan Museum of Art, New York, to create a virtuoso double image, in which the head of Voltaire, gazing across at the semi-naked Gala, can also be interpreted as representing a group of women in front of an archway. The evolution of the painting can be traced through the drawing that Dalí himself made of Houdon's sculpture (Private collection), reducing the work to a pattern of black and white shapes. He then adapted these forms in the painting in order to create the alternative image of the women. While two of them wear black and white costumes in the style of seventeenth-century Spain, the third figure, who doubles as the side of Voltaire's head, is dressed in green and purple. The forms that make up the two women on the left also subtly modify the features of Voltaire's face, as recorded in the drawing, especially around the eyes. It has been said that this work exemplifies Dalí's skill at creating alternative images that are mutually exclusive; in other words at any one time the viewer can only perceive either the head of Voltaire or the women in the slave market, but not both simultaneously. This is in fact arguable since, because of the slight distortion of Voltaire's face in the painting, one is continually aware of the presence of the other human forms out of which the bust is created. This does not detract from the force of the image, whose instability gives the work a disturbing and enigmatic quality. Moreover, according to Dalí, the conjunction of Voltaire's face and a slave market was not just a visual accident. As he described it: 'Gala protects me from the ironic and swarming world of slaves. Gala in my life destroys the image of Voltaire and every possible vestige of scepticism.' With typical ingenuity, therefore, Dalí was able yet again to explain the seemingly inexplicable processes of paranoia-criticism.

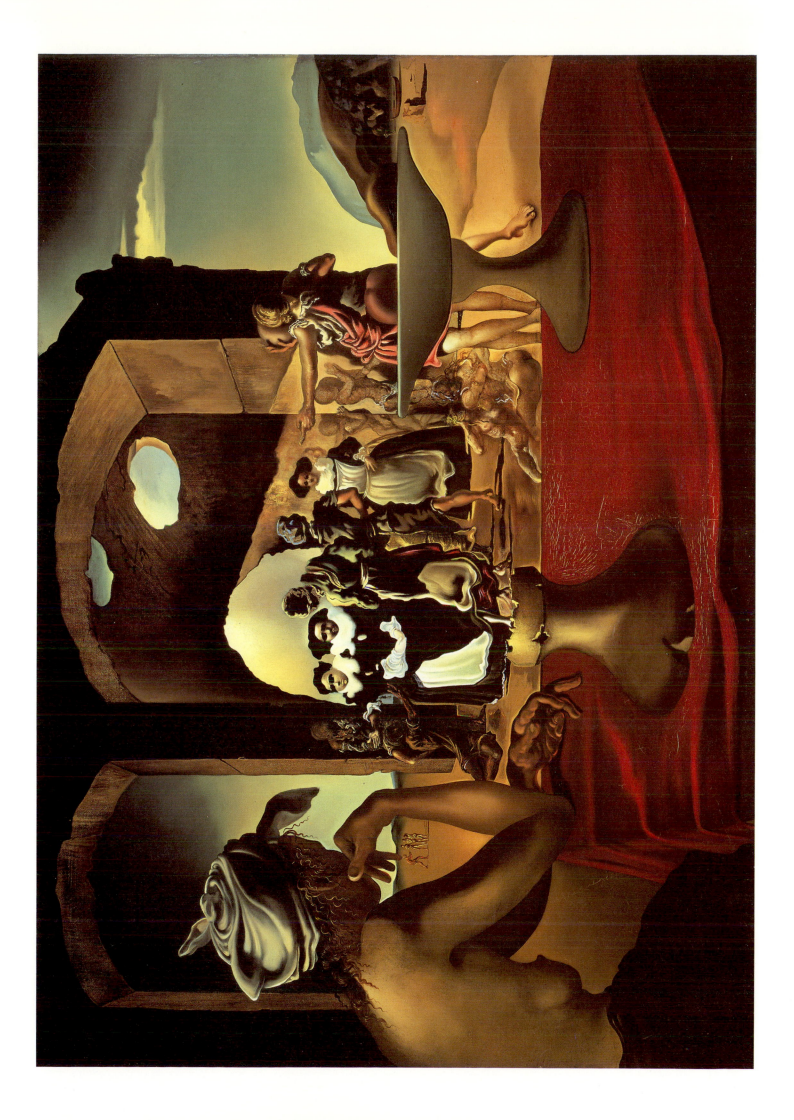

Dream Caused by the Flight of a Bee around a Pomegranate One Second before Awakening

1944. Oil on canvas, 51 x 41 cm. Fundación Colección Thyssen-Bornemisza, Madrid

'Just as the falling of a rod on the sleeper's neck simultaneously causes his awakening and a long dream ending in the blade of a guillotine, here the sound of a bee causes the prick of the spear, which will awaken Gala.' Dalí's descent into kitsch, which characterizes some, although not all, of his later work, could be said to have begun with this peculiar piece of fantasy painting. The subject of a woman lying on a rock had already appeared in 1926 in *Figure on the Rocks* (Plate 7), but the expressive distortion of this painting is completely lacking from the bland classicism of Dalí's post-war nudes, as exemplified by this work and the slightly later *Apotheosis of Homer* (Fig. 33). Understandably, none of the elements of this dream narrative obeys the laws of gravity, but this disregard for physical laws is deliberately combined with a glossy hyper-realism. Dalí could indeed claim that this painting still fulfilled his aim of creating 'hand-done colour photography of the...images of concrete irrationality'. The problem was that as well as scorning rationality, this work unfortunately also seems lacking in anything more than superficial meaning.

Fig. 33
Apotheosis of Homer
1945. Oil on canvas, 63.5 x 117 cm
Staatsgalerie Moderner Kunst,
Munich

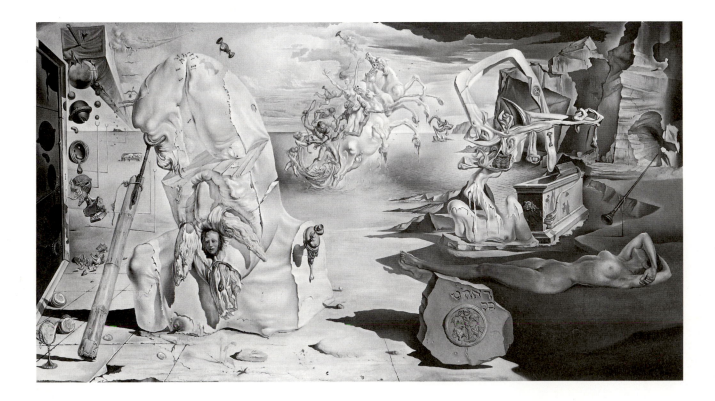

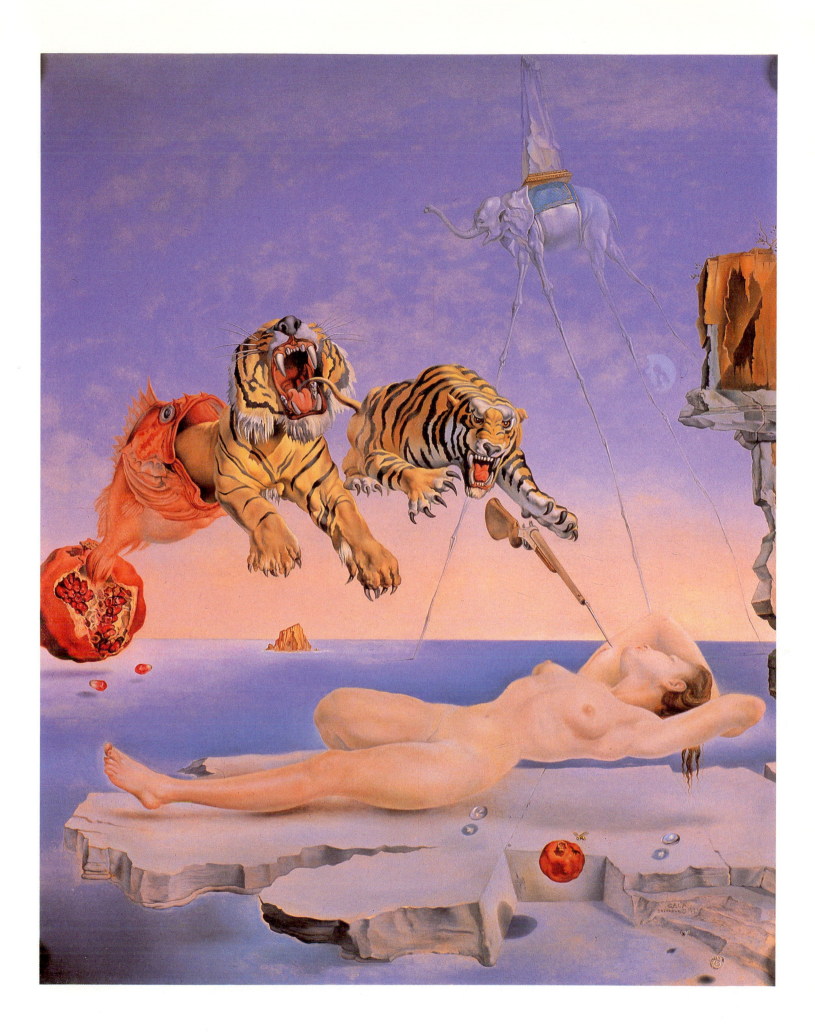

1945. Oil on canvas, 65.5 x 86 cm. Staatliche Museen Preussischer Kulturbesitz Nationalgalerie, Berlin

During his wartime career in America as a society portrait painter Dalí reused the Surrealist technique of paranoia-criticism for the very un-Surrealist purpose of making large amounts of money. This work, painted in Hollywood, owes less to Dalí's own past experiments with double images than to the work of the sixteenth-century Italian artist Giuseppe Arcimboldo (1527–93), who was generally admired by the Surrealists. Arcimboldo's paintings, in which human figures are created out of twigs, leaves and fruit, bear an obvious resemblence to the structure on the left of Dalí's painting. Here paranoia-criticism is reduced merely to substituting natural for human features, with the primacy of Frau Styler-Tas's image never in doubt. Dalí was also influenced by the Italian Renaissance painter Piero della Francesca (c1410–92), as can be seen from a comparison with his double portrait of Federigo da Montefeltro, Duke of Urbino and his wife (see Fig. 34). Four years later Dalí paid Piero a still more ambitious act of homage in *The First Study for the Madonna of Port Lligat* (Plate 39).

Fig. 34
PIERO DELLA
FRANCESCA
Portrait of Federigo
da Montefeltro and
Battista Sforza
c1465. Panel, each 47 x 33 cm.
Galleria degli Uffizi,
Florence

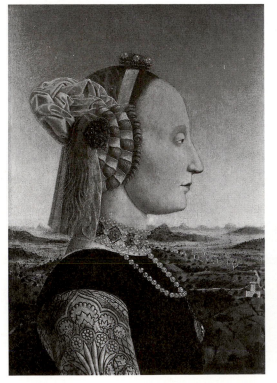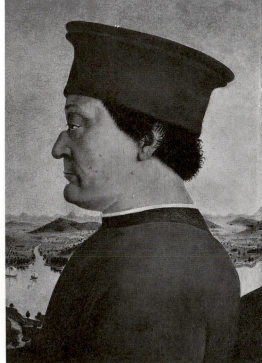

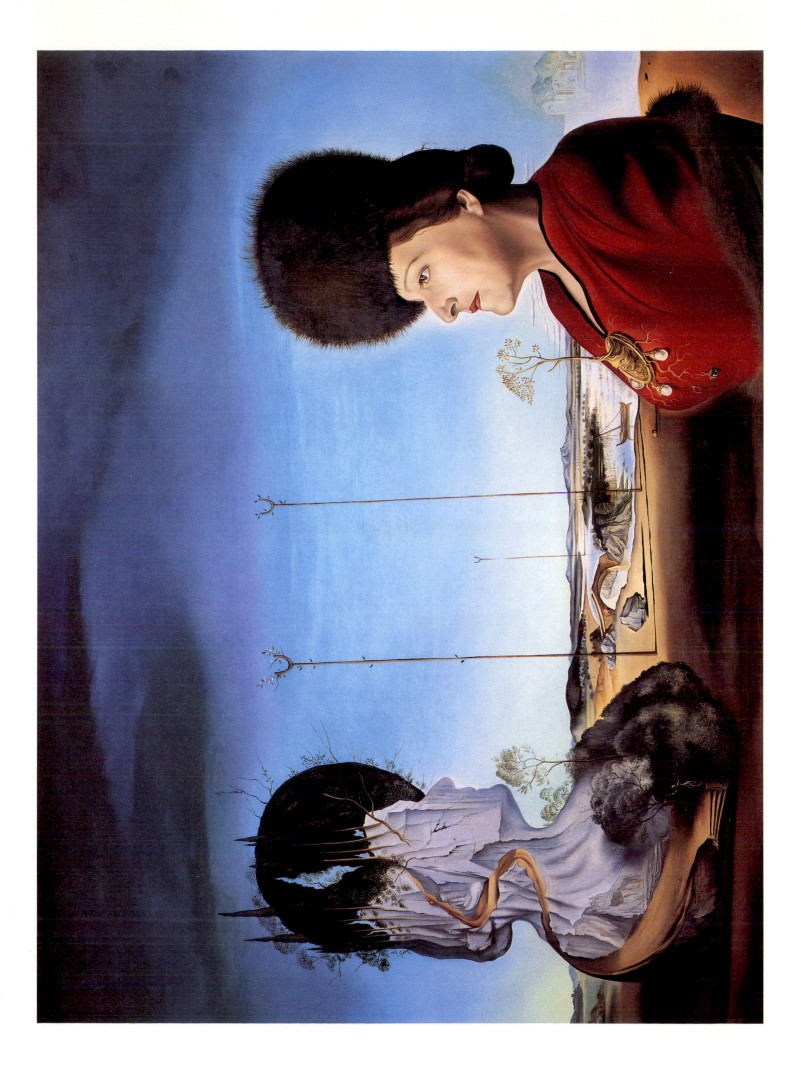

The Temptation of St Anthony

1946. Oil on canvas, 89.7 x 119.5 cm. Musées Royaux des Beaux-Arts de Belgique, Brussels

Dalí obviously thought that the elephant on stilt-like legs which appears in *Dream Caused by the Flight of a Bee around a Pomegranate One Second before Awakening* (Plate 36) was a successful innovation, since this image reappears in multiple form in this slightly later work. While the elevated position of the animals is a symbol of the communion between heaven and earth, the obelisks and other objects that they carry have blatantly sexual connotations, appropriately enough, given the nature of the temptations that St Anthony was supposed to have faced. This subject traditionally provided an excuse for artists to pursue their wildest flights of fancy, but Dalí has surpassed previous representations of the saint with this extraordinary image. Although the elephant bearing a pyramidal obelisk was borrowed from the Italian Baroque sculptor Gianlorenzo Bernini (1598–1680), other motifs, such as the animal carrying the Cup of Desire, were more individual to Dalí. In the background Dalí has included an image with a particularly strong personal significance, the Palace of the Escorial outside Madrid, which for him symbolized the union between the spiritual and temporal orders.

The original purpose of *The Temptation of St Anthony* was to win a competition held by Loew Lewin Studios for a painting to be used in the film of Maupassant's novel *Bel-Ami*. The contest was in fact won by the German painter Ernst. While the work has never attracted much critical approval, the popularity of its fantastic imagery did not escape museum curators, and it was acquired by the Musées Royaux des Beaux-Arts de Belgique in Brussels.

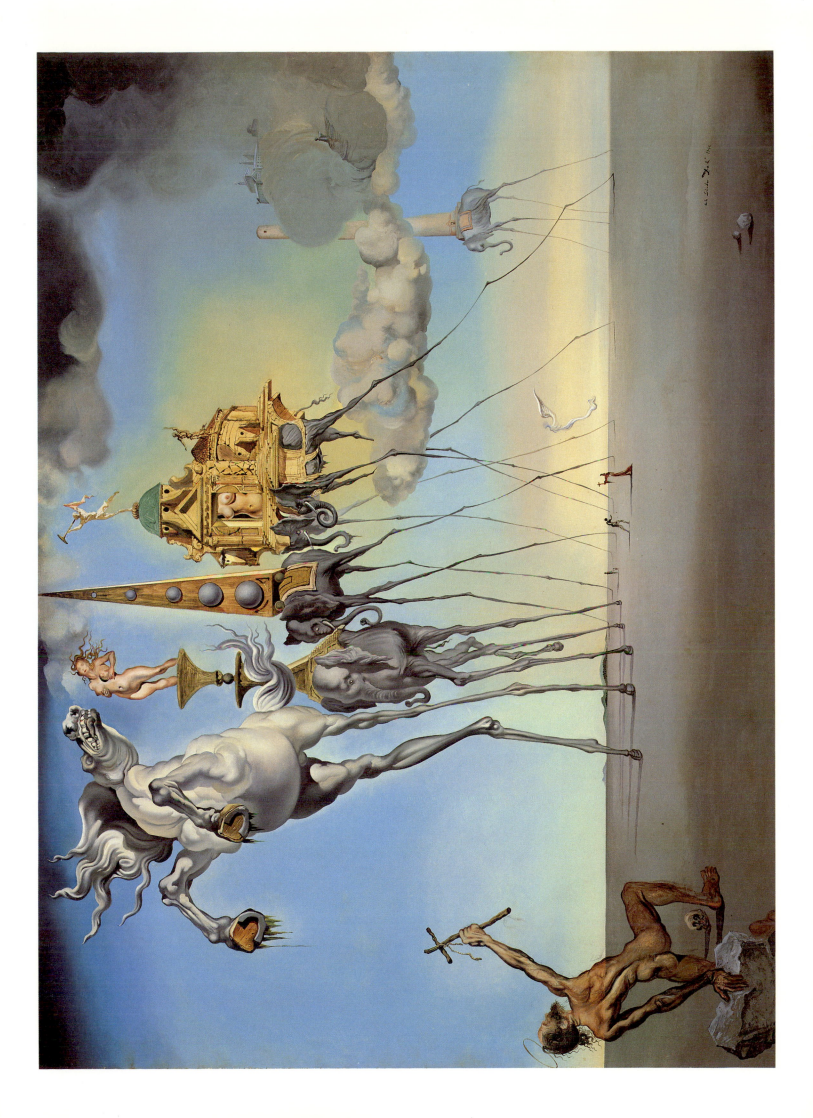

39 The First Study for the Madonna of Port Lligat

1949. Oil on canvas, 48.9 x 37.5 cm. The Patrick and Beatrice Haggerty Museum of Art, Marquette University, Milwaukee, WI

Dalí's new enthusiasm for the Catholic Church was given special recognition in 1949, when he was granted an audience with Pope Pius XII, to whom he presented this curious work, one of two versions (the other is in a private collection). It is clearly based on Piero della Francesca's *Madonna and Child with Angels and Six Saints* (Pinacoteca di Brera, Milan) but, unlike its Renaissance prototype, it punctures and dismembers both the figures and their architectural framework. Dalí explained this 'dematerialization' as 'the equivalent in physics, in this atomic age, of divine gravitation', hardly an orthodox religious position. The highly personal nature of the painting is also strengthened by Dalí's use of his wife Gala as the model for the Madonna. The shell from which an egg is suspended above the Madonna's head also appears in the painting by Piero, although there it is the other way round. The other marine objects reflect Dalí's choice of setting, his own home at Port Lligat. For Dalí the mythologization of his own private life was in no way inconsistent with his renewed Christian faith.

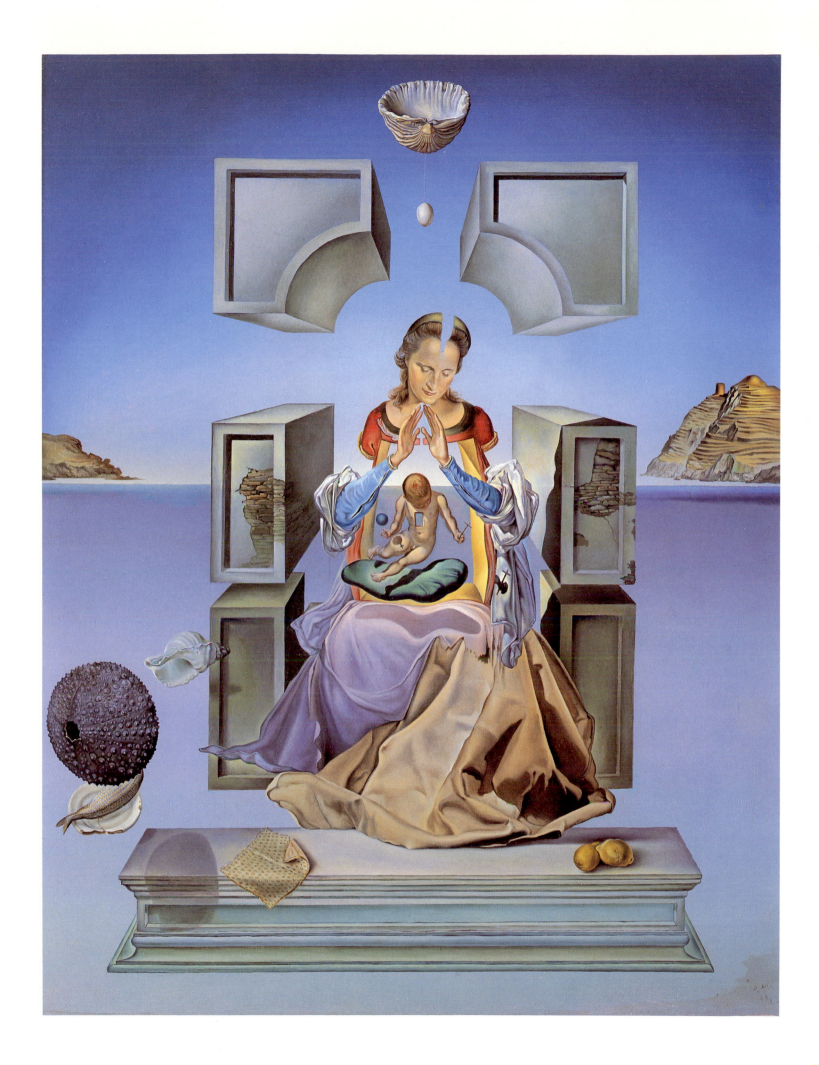

Christ of St John of the Cross

1951. Oil on canvas, 205 x 116 cm. St Mungo Museum of Religious Life and Art, Glasgow

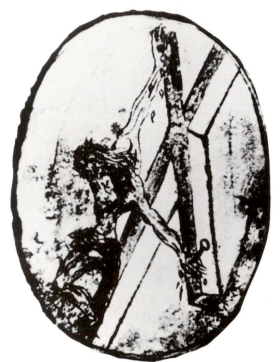

Fig. 35
ST JOHN OF THE
CROSS
The Crucifixion
C16th. Drawing,
dimensions unknown.
Monastero de la
Incarnación, Avila

In this painting, the most spectacular of his religious works, Dalí sought to represent 'the metaphysical beauty of Christ-God'. Dalí described how he used the laws of 'Divine Proportion' developed by the Renaissance geometrician Luca Pacioli to create the triangular form of Christ's body. He was also influenced by a dream in which he saw the image of a sphere inside a triangle. Although Dalí believed that this was a vision of the nucleus of the atom, he later decided to use this composition in his painting of Christ. However, the most important source of inspiration for this work was St John of the Cross's drawing of the Crucifixion (see Fig. 35). Dalí claimed that, having seen this version of the subject, he experienced a dream set in Port Lligat, in which he saw Christ hanging in the same position as in the drawing and heard voices telling him to paint this image himself. This he then did, with all his powers of virtuosity, using a Hollywood stuntman as his model. As well as its remarkable foreshortening and dramatic chiaroscuro the quality that distinguishes this work from less audacious Crucifixions is the lack of the crown of thorns and other conventional attributes of the crucified Christ. Again Dalí was able to attribute this to a dream, which inspired him to omit incidental aspects of the subject in order to realize his goal of 'painting a Christ beautiful like the God who He is'. While the *Christ of St John of the Cross* probably does not actually rate among the most beautiful of Crucifixions, its vast scale and bold design have given it lasting appeal.

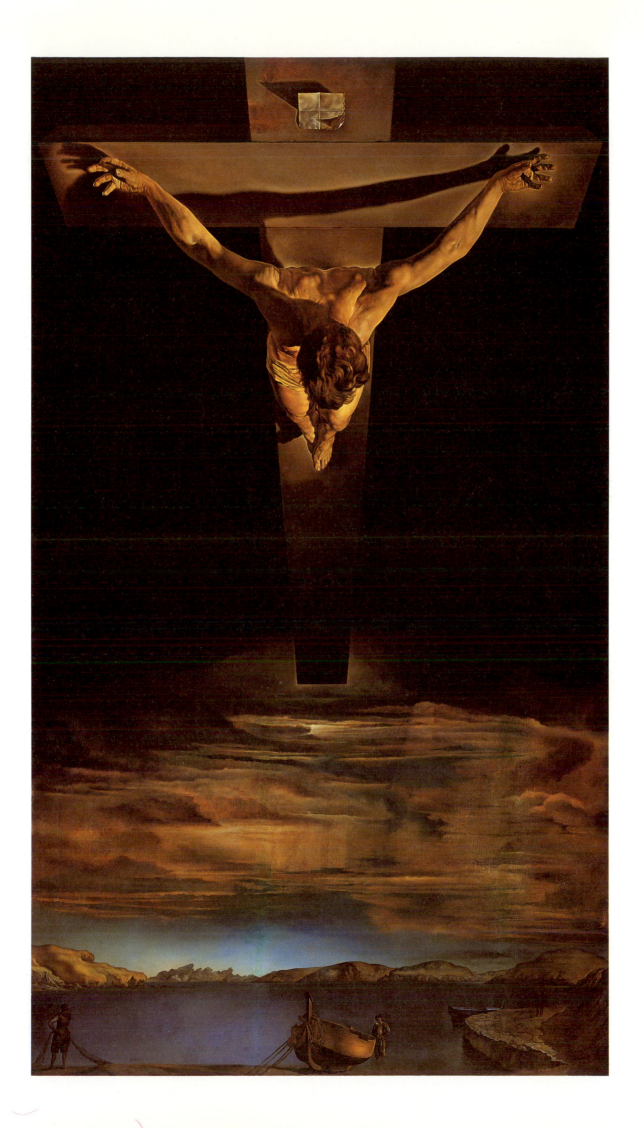

The Disintegration of the Persistence of Memory

1952–4. Oil on canvas, 10 x 13 cm. Private collection, on loan to the Salvador Dalí Museum, St Petersburg, FL

This is one of many works that reuse the soft watches that first appeared in *The Persistence of Memory* (Plate 19). Dalí's quasi-scientific interpretation of the earlier painting, which he related to the theory of relativity, is developed in this later version. Like the dismembered figures in *The First Study for the Madonna of Port Lligat* (Plate 39), the disintegrating watch and olive tree are metaphors for Dalí's understanding of nuclear physics, while his own description of the work also alludes to genetics. As he wrote: 'after twenty years of total immobility, the soft watches disintegrate dynamically, while the highly coloured chromosomes of the fish's eye constitute the hereditary approach of my pre-natal atavisms.'

The presence of the fish also emphasizes that Dalí has relocated the imagery of *The Persistence of Memory* (Plate 19) in a strange submarine environment. Moreover, as in *Still Life by Moonlight* (Plate 8), the fish's form is reflected in other parts of the painting: in particular the drooping face of Dalí on the right recalls the animal's features, especially the fins covering its gills and the coloured streak running down its body. While Dalí's self-portrait has taken on a distinctly marine quality, the surface of the sea has itself been transformed into a kind of skin, hanging from a tree like one of the soft watches themselves. Once again Dalí has shown his determination to pursue to the absolute limit a particular obsession, in this case his fascination with softness and pendulousness.

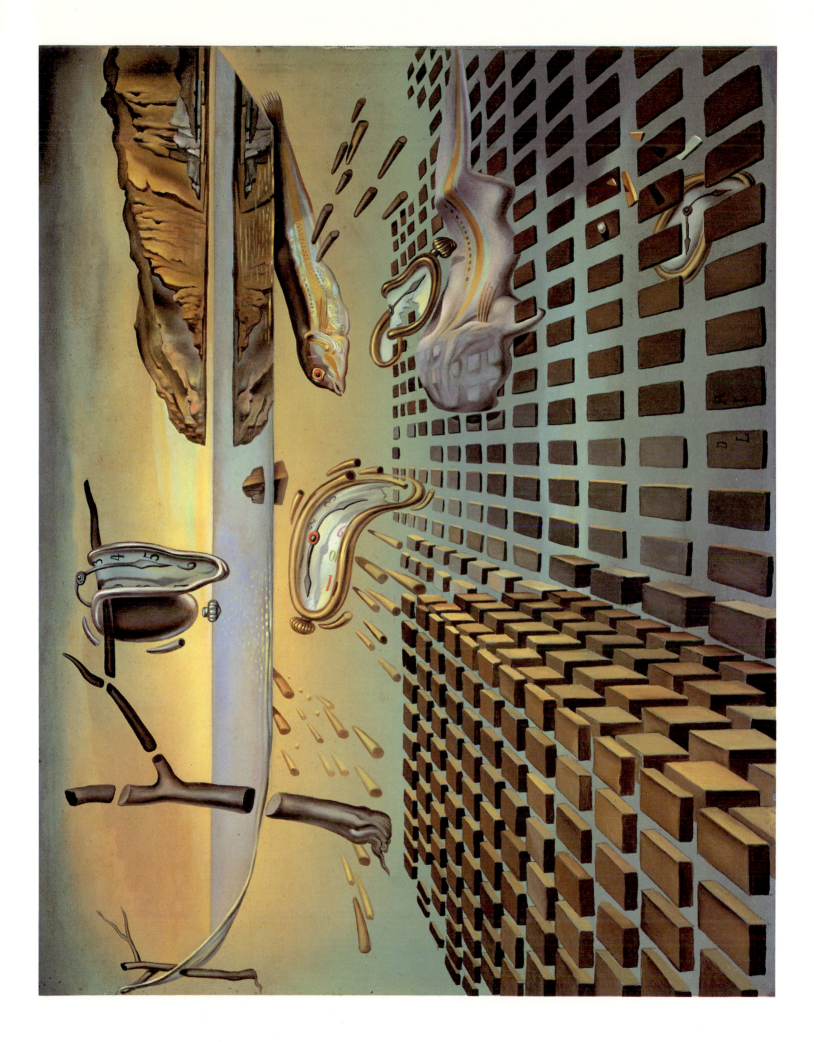

Crucifixion or Corpus Hypercubicus

1954. Oil on canvas, 194.5 x 124 cm. Metropolitan Museum of Art, New York

Dalí's Spanish heritage was the principal source of inspiration for this ambitious and idiosyncratic Crucifixion. Like *Christ of St John of the Cross* (Plate 40), the painting is indebted stylistically to the Spanish painter Francisco de Zurbarán (1598–1664). However, its most unusual features, the cubes out of which the cross is constructed, derive from Dalí's reading of a sixteenth-century treatise, the *Discourse on Cubical Form* by the architect Juan de Herrera. In Dalí's eyes Herrera was a particularly significant figure as he designed the Escorial Palace outside Madrid, to which he had already referred in *The Temptation of St Anthony* (Plate 38). Dalí's reliance on Herrera's theories was unexpectedly supported by a group of nuclear physicists, who saw the picture in his studio while it was still unfinished. For them the image suggested a remarkable analogy with the cubic form of the crystallization of salt photographed in space. Fortunately they were not the only admirers of the work. While Dalí's religious paintings were received with disgust by most critics, the distinguished collector Chester Dale was overwhelmed by this work when it was exhibited at the Carstairs Gallery, New York, in 1955, and as a result bought it for the Metropolitan Museum of Art.

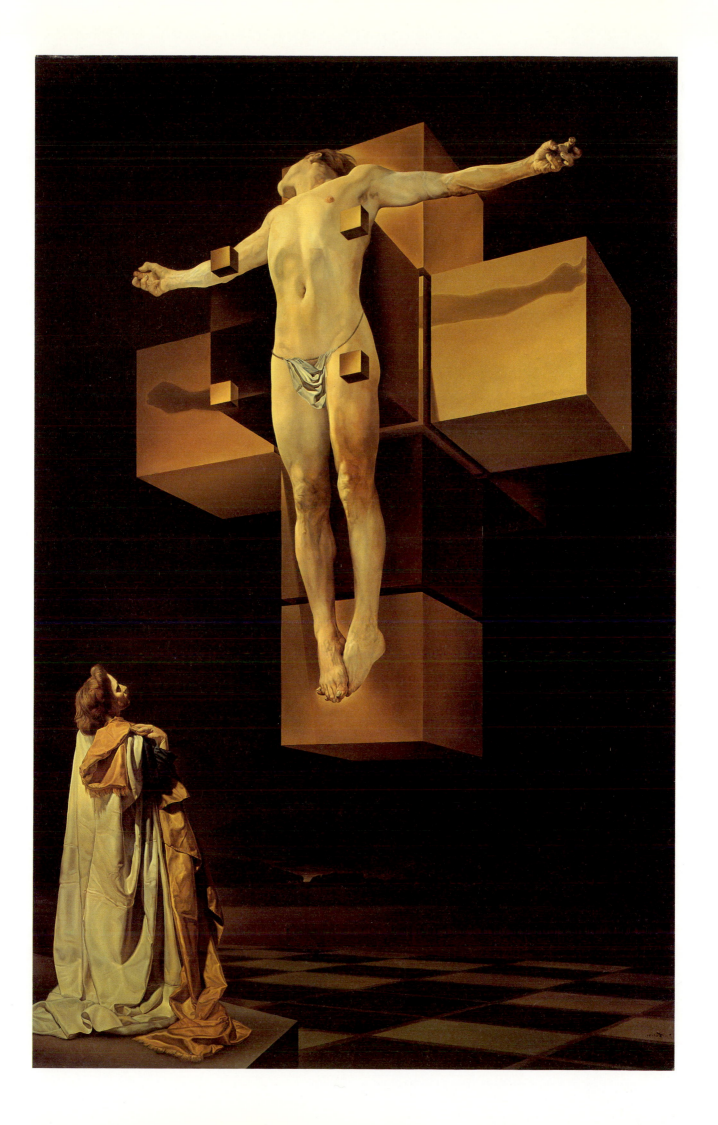

The Sacrament of the Last Supper

1955. Oil on canvas, 167 x 268 cm. National Gallery of Art, Washington DC

Chester Dale's admiration for Dalí also led him to make this ambitious commission. As in *Christ of St John of the Cross* (Plate 40), Dalí has stripped the image down to its bare essentials, clearing the table of everything but the sacramental bread and wine. His idea of sacred beauty, exemplified by the transparent, ghost-like form of Christ, also led him to declare that 'the Communion must be symmetrical', a principle rigorously adhered to in this painting. The setting is a dodecahedral room, expressing Dalí's belief in 'the paranoiac sublimity of the number twelve', which was the number of Christ's apostles, as well as the months of the year and the signs of the zodiac. The disciples themselves are deliberately denied any individuality in order to emphasize Dalí's idealization of his subject. In attempting to transcend the story's human dimension, however, Dalí has created a remarkably bland painting. It lacks the drama that characterizes Leonardo da Vinci's *Last Supper* (Sta Maria delle Grazie, Milan), for example, which depicts the moment when Christ reveals that one of the apostles will betray him. Nonetheless, Chester Dale, who owned an impressive array of Impressionist and Modern works, supported his commission by comparing Dalí not to Leonardo but to a familiar contemporary competitor: 'I consider Picasso a very great painter. I have fifteen of his canvases in my collection, but never will he paint a picture to equal Dali's Cena, for the very simple reason that he is not capable of doing so.'

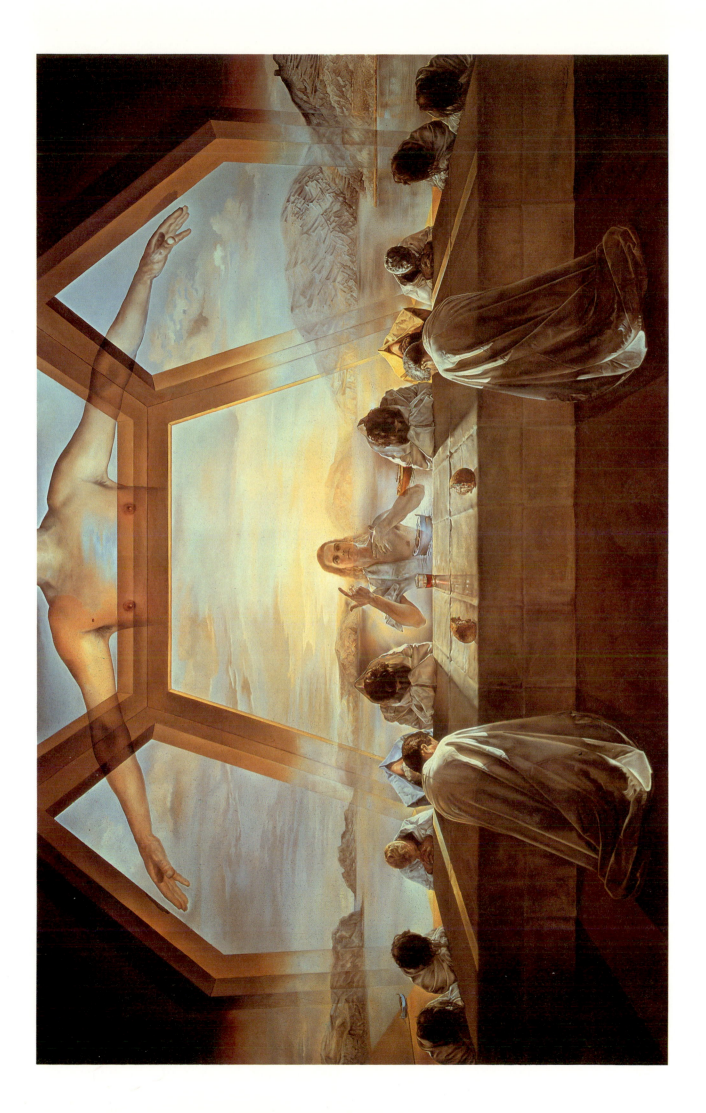

Still Life – Fast Moving

1956. Oil on canvas, 125.7 x 160 cm. Salvador Dalí Museum, St Petersburg, FL

In 1956 Dalí produced a number of works that reflected his developing interest in modern physics. Some, such as *Anti-protonic Assumption* (Private collection) once again had a strong religious component. *Still Life – Fast Moving*, on the other hand, is entirely secular and makes a direct allusion to Port Lligat where it was painted. Here it is the mundane elements of a conventional still life that are depicted in mid-air, in some state of confusion, as a metaphor for the new scientific theory of quantum mechanics, which was concerned with the unpredictable movements of sub-atomic particles. The painting also enthusiastically expresses Dalí's obsessive interest in the logarithmic spiral, a recurrent natural form which was later proven to be the shape of DNA. The spiral appears most spectacularly in the base of the fruit-dish whirling around in the upper part of the painting, as well as in the cauliflower to the right. Dalí was particularly fascinated by the structure of rhinoceros horns, and it is no surprise to find one of these clasped by a disembodied hand on the left of the picture.

This eccentric quasi-scientific imagery was the product of a profound shift in Dalí's interests. As he put it soon afterwards in his *Manifesto of Anti-matter*, during his Surrealist period he had wanted 'to create the iconography of the inner world' and his spiritual father had been Freud, but later 'the exterior world, that of physics … transcended that of psychology', and so his 'father' became Dr Heisenberg, the pioneer of quantum theory. It is not difficult to see that Dalí had been far more successful at exploring his own psychological obsessions than he was at representing new scientific theories, of which, as he admitted, he had little actual knowledge. Indeed his depiction of objects from everyday reality behaving as if they were sub-atomic particles seems faintly ridiculous, as well as scientifically inaccurate. However, this incompetence is not the main weakness of these paintings; above all they are extremely impersonal in comparison to his vivid images of his own desires and fears.

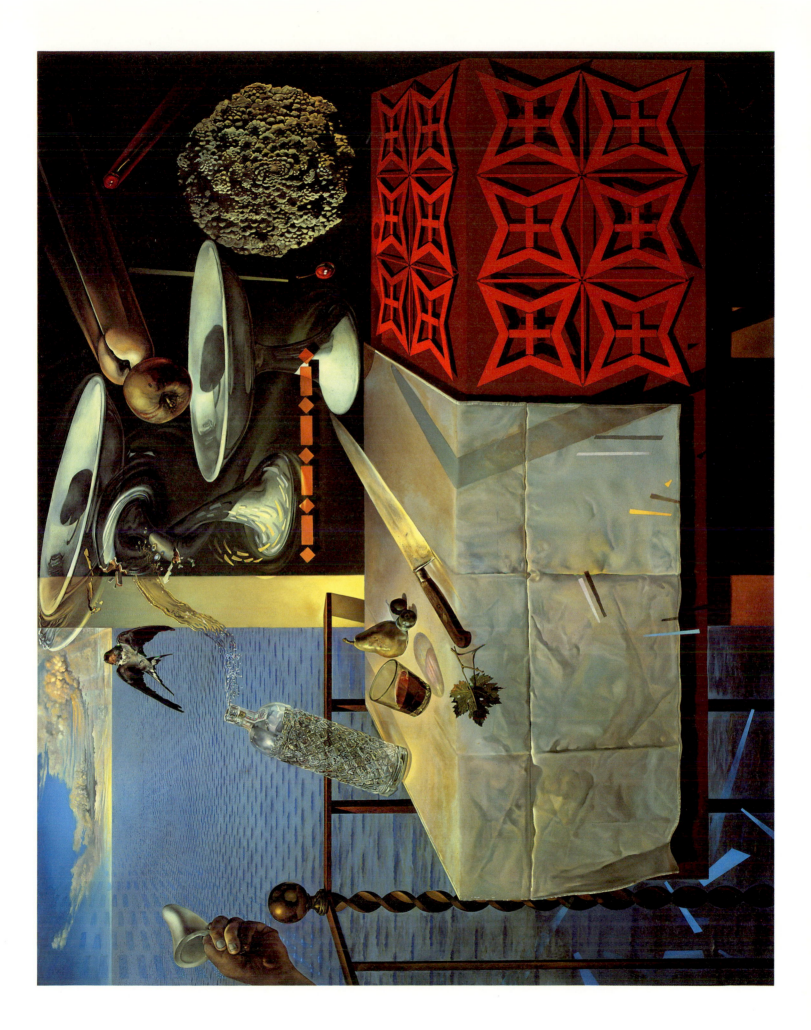

Velázquez Painting the Infanta Margarita with the Lights and Shadows of his own Glory

1958. Oil on canvas, 153 x 92 cm. Private collection, on loan to the Salvador Dalí Museum, St Petersburg, FL

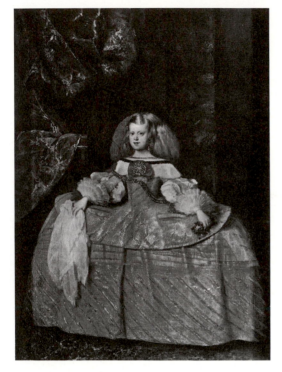

Fig. 36
Diego Velazquez
The Infanta
1660. Oil on canvas,
127.5 x 107.5 cm.
Museo Nacional del
Prado, Madrid

Dalí's admiration for Velázquez had begun when he was a youth. At the age of 15 he had set up a short-lived magazine called *Studium*, for which he wrote an essay on Velázquez as one of a series of articles entitled 'The Great Masters of Painting'. Even during his Surrealist period he held up the realism of Velázquez and Vermeer as the means by which he could 'materialize the images of concrete irrationality'. As the 300th anniversary of Velázquez's death approached, Dalí decided to produce this painting based on *The Infanta* of 1660 (Fig. 36). However, with characteristic eclecticism he reproduced Velázquez's imagery in a contemporary style derived from American Abstract Expressionism. Dalí, who himself had achieved such enormous success in America, identified in particular with Willem de Kooning (b. 1904), the Dutch-born Abstract Expressionist resident in New York, or as Dalí chose to put it, 'the colossus straddling the Atlantic with one foot in New York and the other in Amsterdam'. While the exuberant brushstrokes of Dalí's work undoubtedly show De Kooning's influence, they also make references to Dalí's current scientific interests. The left hand of the Infanta, for example, was inspired by tracks of atomic particles on photographic film, while her head is composed, naturally, of rhinoceros horns. Despite these allusions to modern scientific and artistic discoveries, the top left-hand corner of the painting contains a detailed depiction of a room in the Prado, as if to emphasize Dalí's debt to the Old Masters and, in particular, to his Spanish predecessors.

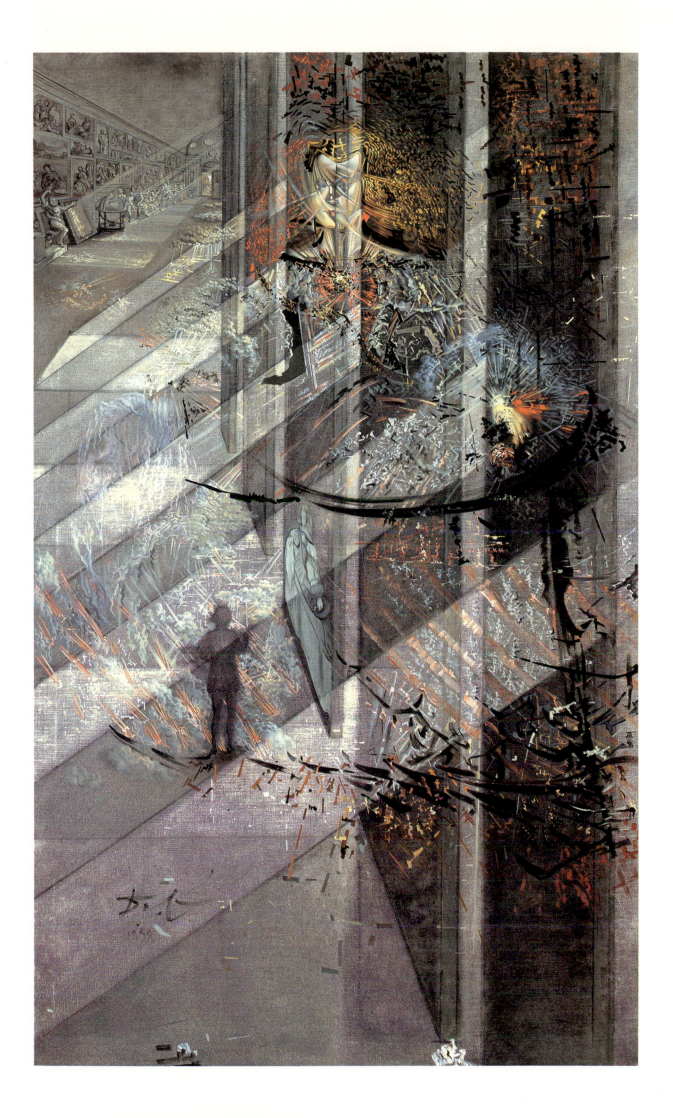

The Discovery of America by Christopher Columbus

1958–9. Oil on canvas, 410 x 310 cm. Salvador Dalí Museum, St Petersburg, FL

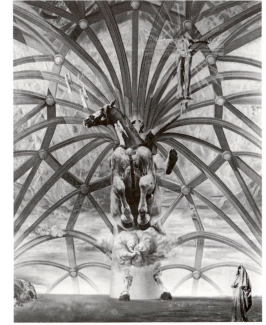

Fig. 37
Santiago el Grande
1957. Oil on canvas,
400 x 300 cm.
Beaverbrook Art Gallery,
Fredericton, NB

Dalí's interest in Spanish history, and his particular fascination with Spain's tradition of piety, are reflected in this work and also in *Santiago el Grande* (Fig. 37), an extraordinary icon of the revered Saint James of Compostela. While *The Discovery of America by Christopher Columbus* is intended to continue the tradition of history painting, it also certainly had a private significance for Dalí, who personally identified with Columbus; not only was the explorer a Catalan, according to Dalí's implausible assertion, but more importantly his discovery of America was reflected in the artist's own success in that continent. In Dalí's eyes Columbus's achievement was also directly comparable to the new scientific breakthroughs in which he took such a keen interest. Significantly Dalí symbolized Columbus's realization that the world was round by painting a giant sea urchin in the foreground of the picture, with an oval rather than circular shape. Soon afterwards he was able to claim prophetic abilities when a satellite, which Dalí had represented orbiting the sea urchin, revealed that the earth was not in fact a perfect globe.

The closeness of Dalí's identification with Columbus gives added significance to his customary habit of filling his paintings with personal references, most noticeably the depiction of Gala on Columbus's banner of the Immaculate Conception. Less obvious is the suggestive landscape, possibly of Cape Creus, in the background of the painting, and the figure of St Narcisus, the patron of Dalí's province, who is the bishop welcoming Columbus to the New World. The religious imagery in the painting also includes a reference to Dalí's own work *Christ of St John of the Cross* (Plate 40), in which he has reproduced the lines of a photographic engraving, but magnified so greatly that they merge with the halberds of the Spanish soldiers. As is typical of so much of his later work, Dalí has created a deliberately conservative painting that nonetheless combines technical experimentation with allusions to the most modern scientific developments.

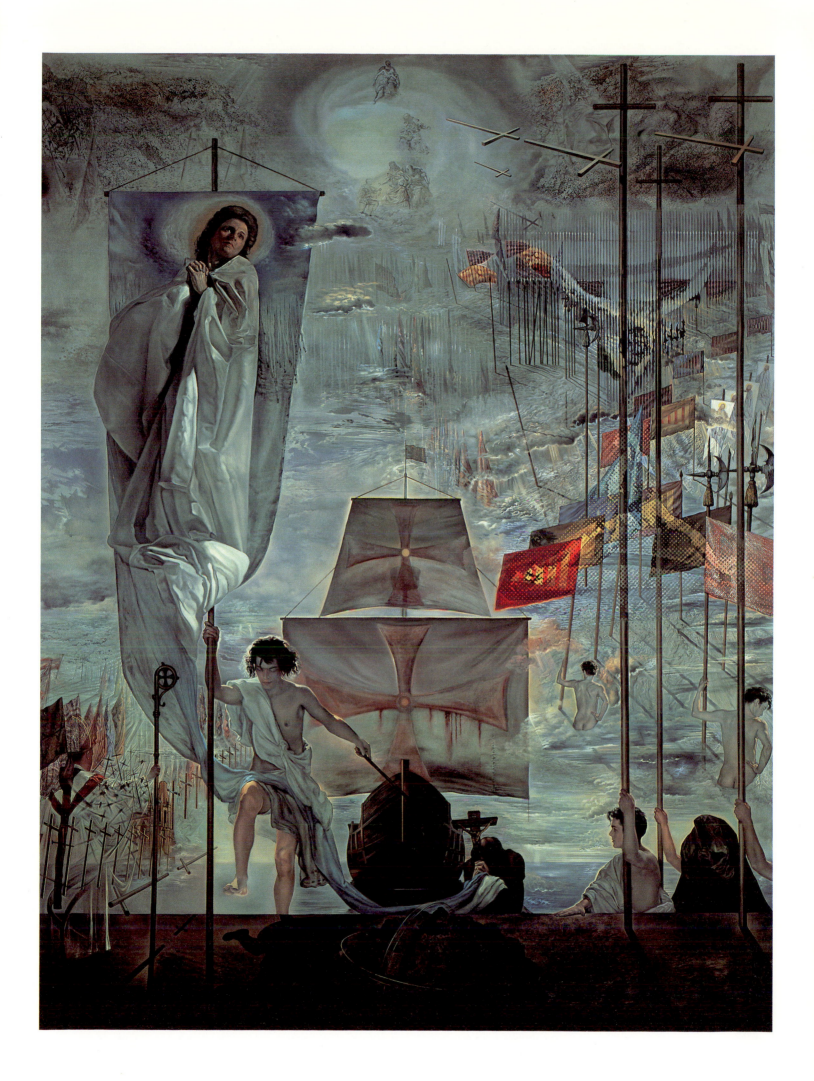

Tuna Fishing (Homage to Meissonier)

1966–7. Oil on canvas, 400 x 300 cm. Private collection

In November 1967 Dalí organized an exhibition at the Hotel Meurice in Paris, in which he showed this monumental work, which had occupied him over the previous two summers. He claimed that its theme was prompted initially by his father, who used to tell him an epic story about a tuna catch and also had a print of the subject in his study. Dalí endowed the act of tuna fishing with a metaphysical significance that derived from his reading of the modern French writer Pierre Teilhard de Chardin and from the discoveries of modern physics. These, he claimed, taught him to realize that the universe and the cosmos were finite, and that 'all the elementary particles have their miraculous, hyper-aesthetic energy solely because of the frontiers and contraction of the universe.' Dalí's decision to represent this extraordinary energy concentrated in the bloodthirsty spectacle of the tuna catch also allowed him to represent graphically another of his convictions, that 'every birth is preceded by the miraculous spurting of blood.'

The extent of Dalí's ambition in this painting is indicated by the fact that its first showing was accompanied by an exhibition, organized by Dalí, which was devoted to Meissonier and other nineteenth-century academic artists who had 'assimilated the history of our times itself, in all its complexity, density, inevitability, tragedy'. Certainly the scale of the painting and aspects of its style demonstrate Dalí's desire to continue the achievements of his predecessors. Characteristically, however, Dalí combined traditional techniques, such as the use of live models, with more modern methods. The classical figure on the left, for example, was painted from a photograph stuck onto the canvas, while the man in a T-shirt in the foreground was taken from an advertisement, a reference to commercial imagery that clearly reflects the influence of contemporary Pop art. With its extraordinary eclecticism and monumental scale this painting does perhaps merit Dalí's own judgement of it as 'the most ambitious picture I have ever painted'.

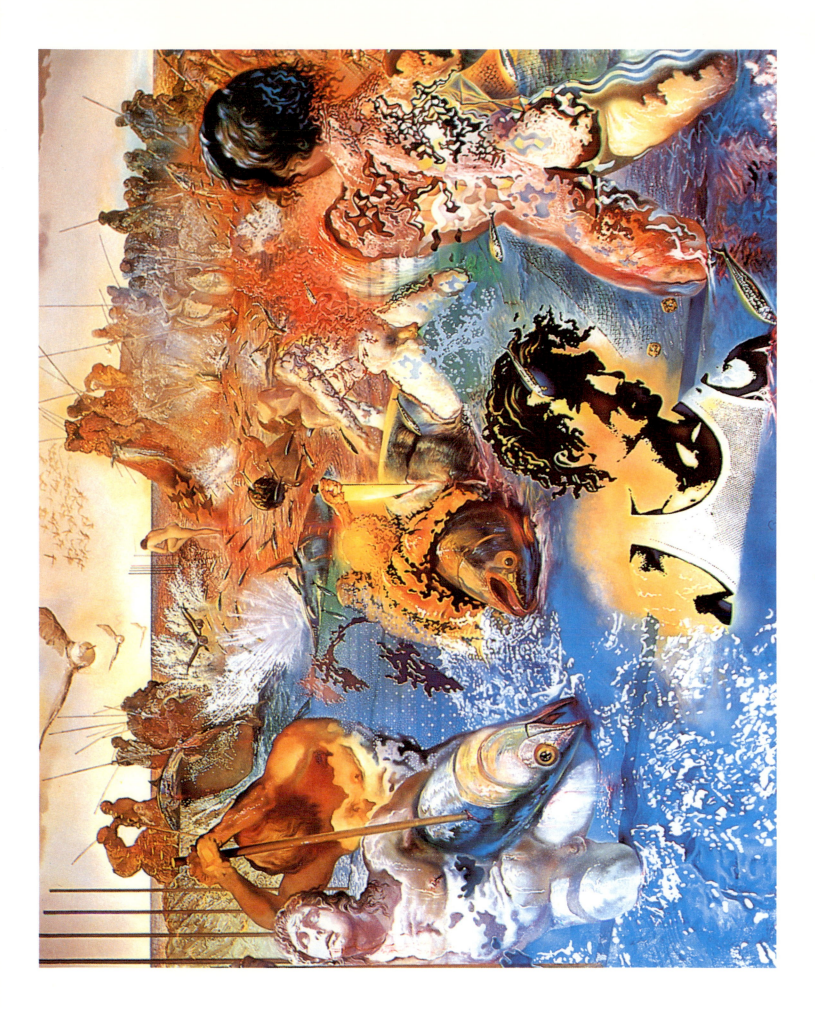

Hallucinogenic Toreador

1969–70. Oil on canvas, 400 x 300 cm. Salvador Dalí Museum, St Petersburg, FL

Not merely did Dalí revive his paranoiac-critical technique for this painting, but he also included specific allusions to works that he had made decades previously. He himself appears in the bottom right as the little boy in the sailor-suit from *The Spectre of Sex Appeal* (Plate 23), while another familiar motif, Houdon's sculpture of Voltaire (see plate 35), floats in front of the drapery covering the famous classical statue of the *Venus de Milo* (Musée du Louvre, Paris). The *Venus de Milo* herself had already appeared years previously in one of the most famous Surrealist objects, the *Venus de Milo with Drawers* (Private collection), which Dalí had designed, although it was actually completed by his fellow Surrealist Duchamp. In *Hallucinogenic Toreador* the Venus reappears in a receding line of figures, out of which is formed the image of the toreador's head, with a single tear falling from his right eye. The paranoiac-critical phenomenon from which the work derives was in fact caused by a packet of Venus de Milo pencils, in which Dalí perceived the head of the toreador. This is similar to Dalí's much earlier experience with a tea-service containing multiple reproductions of *The Angelus*; the fact that both works of art had become such popular icons indicated that they had a strong latent meaning which made them especially ripe for paranoiac-critical interpretation. While *Hallucinogenic Toreador* recalls some of the themes of Dalí's early career, it also reflects his more recent experiments. The optical effects created by contemporary Op art, for example, inspired the pattern of coloured dots above the head of the bull on the left of the painting. With characteristic ingenuity, Dalí makes these dots gradually metamorphosize into rows of flies, emphasizing how even the most abstract motifs are subordinate to the overwhelming representational element in his work.

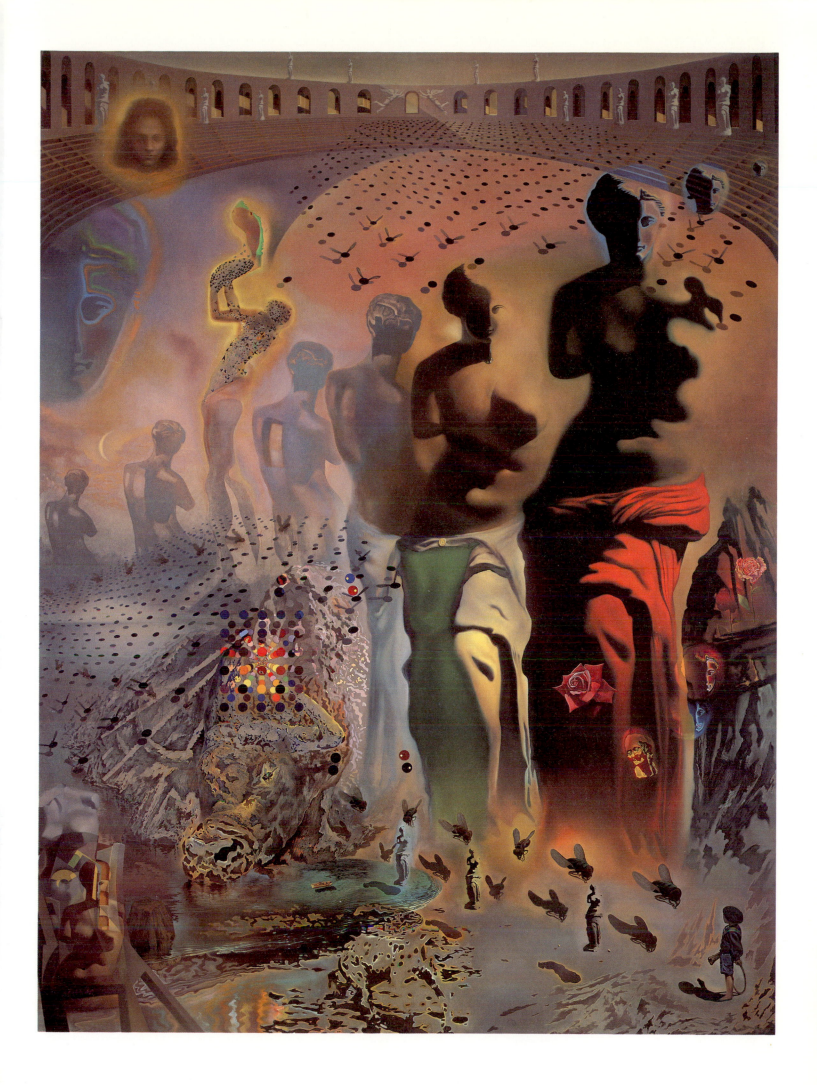